IMAGES
of Aviation

CLEVELAND'S
LEGACY OF FLIGHT

On the cover: Shown during their tenure at the Glenn L. Martin Company in Cleveland, Donald Douglas, left, and Larry Bell, right, stood on the threshold of exceptional careers in aviation. After their Cleveland days, both men went on to form major aircraft companies and became honored figures in aviation history. (Author's collection.)

IMAGES
of Aviation

CLEVELAND'S LEGACY OF FLIGHT

Thomas G. Matowitz Jr.

ARCADIA
PUBLISHING

Published by Arcadia Publishing
Charleston, South Carolina

Printed in the United States of America

Library of Congress Catalog Card Number: 2007939005

For all general information contact Arcadia Publishing at:
Telephone 843-853-2070
Fax 843-853-0044
E-mail sales@arcadiapublishing.com
For customer service and orders:
Toll-Free 1-888-313-2665

Visit us on the Internet at www.arcadiapublishing.com

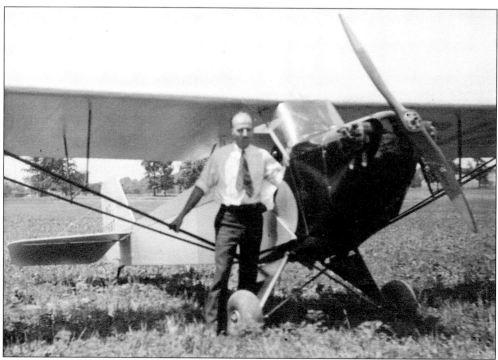

George K. Scott poses with his E-2 Taylor Cub at Lost Nation Airport in Willoughby, Ohio, in the summer of 1933. The direct ancestor of the Piper Cub introduced just a few years later, the Taylor Cub introduced many aspiring pilots to the air. Scott introduced many aspiring pilots to the air himself during a 40-year career as a flying instructor. One of them was his grandson Thomas G. Matowitz Jr., who gratefully dedicates this book to his memory. (Author's collection.)

CONTENTS

ACKNOWLEDGMENTS

Many good friends helped with the preparation of this of this book, and I thank them. Larry Sunyak kindly permitted me to use a great selection of photographs from the collection of his late father, John Sunyak, whose collection of photographs represented a life's work. Don Berliner responded promptly and fully to every request for information, and his help is much appreciated. Tony Ambrose also provided some much needed help to get the details right. Eric Olson, manager of the Medina Airport, provided a nice photograph of this familiar airport as it once looked 50 years ago. Molly Tewksbury loaned several good photographs documenting her mother's days as a United Airlines stewardess based in Cleveland in the 1930s. I am grateful to Teresa Day at the Kansas Aviation Museum for permission to use photographs from the Robert J. Pickett collection. I also wish to thank Adam Snelly for his kindness in loaning several photographs from his personal collection.

I don't see how a book like this would be possible without the help of Lynn Duchez Bycko at the Special Collections Department of the Cleveland State University Library. She and I have been through this process several times now, and she remains notable for her unfailing courtesy and cooperation. My new friend Bill Lehman kindly loaned some outstanding photographs from his personal collection, and I am very grateful.

For as long as I can remember, I have firmly believed that the finest people I've ever known have been the friends I've made through aviation. Nothing has reinforced this conviction more than my association with Pete and Karl Engelskirger. For nearly 10 years, they have introduced me to new flying challenges while sharing their extraordinary range of knowledge about old airplanes. I'm still searching for adequate words to thank them.

Thomas G. Matowitz Jr.
September 30, 2007
Mentor, Ohio

INTRODUCTION

Noted German fighter pilot and Cleveland National Air Races performer Ernst Udet wrote an autobiography titled *Mein Flieger Leben*, or "my flying life." This book is an effort to tell, in pictures, the story of Cleveland's flying life.

Like any other story of a long life, this one has moments of triumph and sadness, as well as tedium and exhilaration. It began almost a century ago. Some of aviation's most colorful characters began their careers here or played prominent roles in Cleveland's aviation history. Donald Douglas and Larry Bell began their aviation careers as young men in Cleveland. Thirty years later they were responsible for one of the most successful lines of commercial airliners ever built and the X-1 rocket plane which broke the sound barrier.

The National Air Races drew worldwide attention and vast crowds to Cleveland regularly for 20 years. The pilots who participated became pop culture heroes and carry names that resound to this day. Jimmy Doolittle, Roscoe Turner, Benny Howard, Dick Becker, and Cook Cleland all became legends in Cleveland, and went on to even greater achievements in later life.

Average people became fascinated by flying as well, and their interest was manifested by the large number of airports quickly established in Cleveland. In those days, all it took was a large grass field and a windsock. Flight instruction in the area began with 100-hour pilots teaching students skills they had barely mastered themselves. Wacos and Swallows gave way to Taylor Cubs and J-3s, which in their turn made way for Piper Cherokees and Cessna 150s. To this day, the sky near Cleveland remains a classroom for neophyte pilots as they learn to fly under the watchful eyes of their instructors.

Many of the airports where these activities took place in the 1920s remain in use today. Some of them, like Lost Nation in Willoughby and Cleveland Hopkins International in Cleveland, have been in continuous operation now for more than three-quarters of a century. A number of others are gone now, long since consigned to development, forgotten flying fields where the sound of aircraft engines has not been heard for generations. One of the most unusual airports in the Cleveland area is Burke Lakefront, created from landfill in an area where Great Lakes freighters once anchored in 40 feet of water.

Grassroots flying can still be found in Cleveland. Dedicated restorers and tail-wheel instructors have made certain that skills commonly practiced in the 1930s are still in daily use today. Airline flying has been a part of the Cleveland aviation scene for eight decades. While new technologies appeared promptly at Cleveland Hopkins International Airport, Island Airlines in Port Clinton flew Ford Trimotors into the 1970s, making Cleveland the last place in the world to see these incredible airplanes in daily use. While Cleveland today has the most sophisticated airliners

and business aircraft to be seen anywhere, it is still possible on a summer day to see an Aeronca C-3 practically hovering in the traffic pattern of a local airport as it arrives to participate in an air show.

Today's Cleveland area pilots can trace their roots back to the racers, airmail pilots, and marathon flyers of the 1920s. While they may not often wear leather jackets and a helmet and goggles today, they are the inheritors of a proud tradition. To see where it all began, it is necessary to look back to the late summer of 1910.

One

CLEVELAND AVIATION'S EARLIEST DAYS

For several years after the Wright Brothers flew at Kitty Hawk, the general public had very little opportunity to observe an airplane in flight. For many Clevelanders, their first chance came in late August 1910. Fresh from his history-making flight down the Hudson River from Albany to New York City, Glenn Curtiss brought his Hudson Flyer to Euclid Beach Park, a well-known amusement park on Cleveland's east side. On August 31, 1910, Curtiss flew from Euclid Beach to Cedar Point, another amusement park located on the lakeshore 64 miles west. He returned the following day, completing the round trip despite being buffeted by high winds and rain on the return leg. The airplane he flew was not done making history. Eugene Ely took off and landed on a temporary platform constructed on board the USS *Birmingham* later that year, thereby giving awed sailors their first glimpse of U.S. Naval aviation.

Other pioneers soon followed in Curtiss's wake. The *Lark of Duluth*, the Benoist seaplane that made the nation's first scheduled airline flight, visited the area in the summer of 1914. By the time the United States entered the First World War, most area residents had seen a Wright Biplane or a Curtiss Pusher firsthand, in some cases flown by a local pilot like Al Engel.

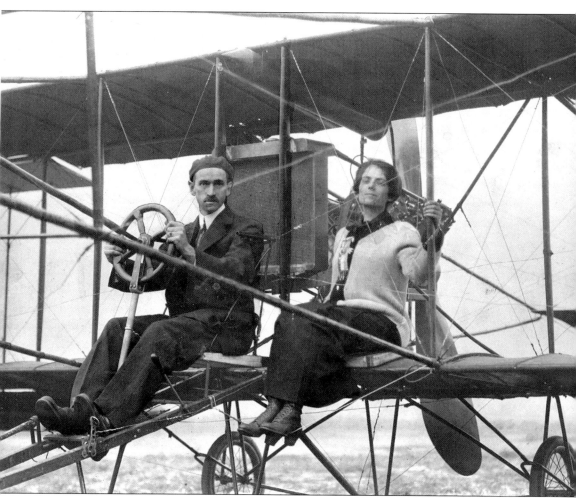

Lucy Price, an intrepid *Cleveland Press* reporter, is seen here about to go up for a flight with Glenn Curtiss at Euclid Beach Park on August 31, 1910. Seated on a cushion, her feet braced against a piece of twine, she will shortly be able to describe the experience of flight to her readers. The event was Cleveland's first media flight and almost certainly the area's first passenger flight. (Cleveland Press Collection, Cleveland State University.)

In the summer of 1910, the fact that an airplane was flying in Cleveland was front page news. (Cleveland Press Collection, Cleveland State University.)

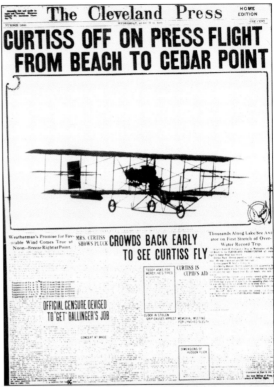

The Cleveland Press

HOME EDITION

CURTISS OFF ON PRESS FLIGHT FROM BEACH TO CEDAR POINT

CROWDS BACK EARLY TO SEE CURTISS FLY

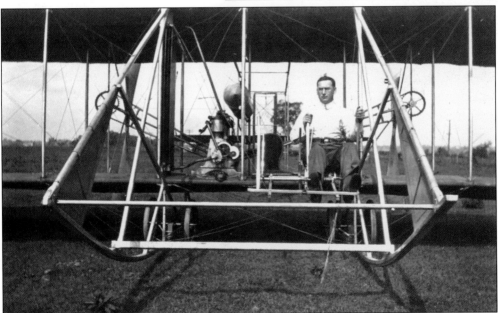

This Wright Model B is typical of the earliest airplanes seen in Cleveland. The pilot and his passenger sat on the leading edge of the lower wing completely exposed to the slipstream. This aircraft's control system differed greatly from later airplanes. Wright airplanes did not have ailerons. Their wings were lightly built and actually twisted in response to control inputs, a process known as wing warping. (Author's collection.)

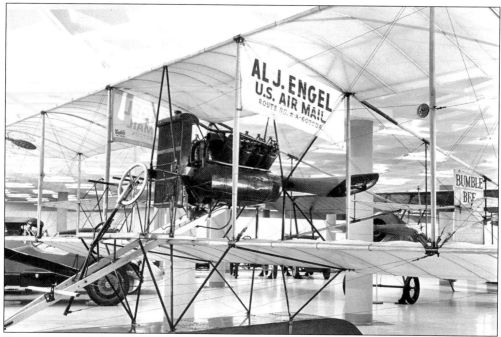

Here is a view of Al Engel's Curtiss Hydroplane. Known as the *Bumblebee*, it has been on display at the Crawford Auto-Aviation Museum for many years. (Cleveland Press Collection, Cleveland State University.)

In this scene depicting key figures from Cleveland aviation's glory days, Fred Crawford, on the left, talks things over with Al Engel. Engel was one of the area's first active pilots, and as the CEO of Thompson Products, Crawford was one of the staunchest supporters of the National Air Races. They were photographed at a reception at the Crawford Auto-Aviation Museum in November 1973. (Cleveland Press Collection, Cleveland State University.)

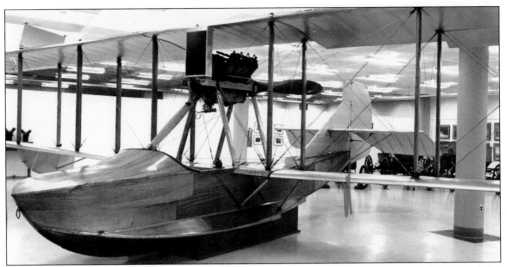

Currently in storage, this World War I vintage Curtiss Flying Boat is in the collection of the Crawford Auto-Aviation Museum. Flown briefly in western Lake Erie after the war ended in 1918, aircraft of this type were instrumental in training America's first naval aviators. (Cleveland Press Collection, Cleveland State University.)

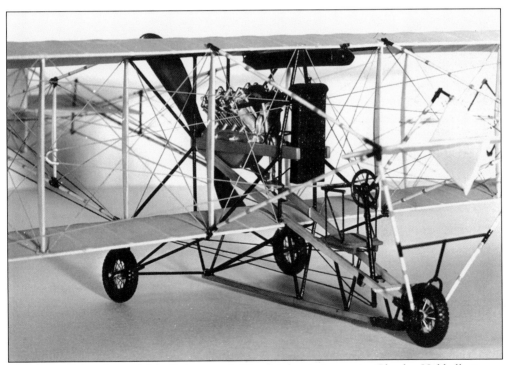

This beautiful scale model built by noted Cleveland aviation artist Charles Hubbell gives a sense of the intricate construction details of early aircraft like the Curtiss Pusher it represents. (Cleveland Press Collection, Cleveland State University.)

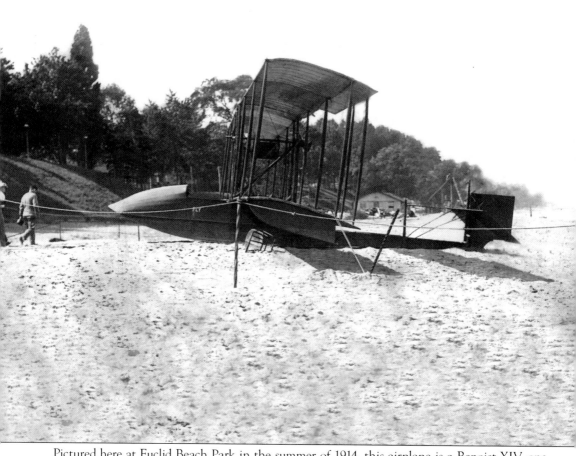

Pictured here at Euclid Beach Park in the summer of 1914, this airplane is a Benoist XIV, one of two constructed the previous year. On January 1, 1914, it earned its place in aviation history books by flying a passenger between Tampa and St. Petersburg, Florida, thereby completing the world's first scheduled airline flight made by an airplane. Known as the *Lark of Duluth*, the airplane was touring the Great Lakes region offering rides when this picture was taken. (Bill Lehman collection.)

Two

AIRMAIL, AIR RACES, AND MARATHON FLYERS

Cleveland city leaders showed great foresight in creating a major airport in Cleveland in 1925, at a time when Charles Lindbergh was as yet unknown. One of its major purposes was to provide facilities for airmail pilots. Cleveland was a major way station along the feared "Hell Stretch," the airmail route across the Alleghenies and the source of some of the most consistently bad weather to be found along the entire coast-to-coast journey.

Weather was rarely a problem for the National Air Races. Presented over a long Labor Day weekend, the event drew pilots and spectators from across the country and was often compared with the Kentucky Derby and the Indianapolis 500. The pre-war racers were a breed apart, largely self-taught pilots and designers who wrote one of the most remarkable chapters in the history of motor racing.

The postwar races pitted young army air force and navy veterans against each other, vying for first place at the controls of 2,000-horsepower aircraft with speeds undreamed of in 1939. Marathon flights were popular in the 1920s and 1930s, and several important ones took place in Cleveland. The city offered something to pique the interest of any aviation enthusiast as those who remember those days can easily attest.

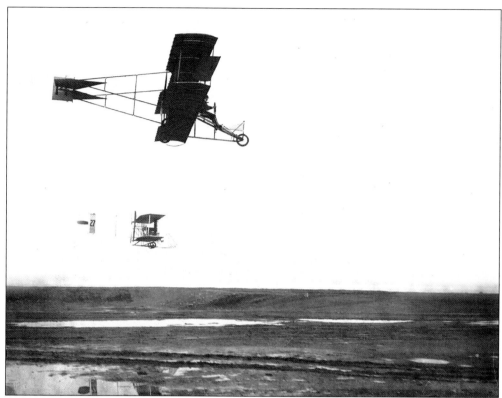

Probably in no danger of violating a 35-mile-per-hour speed limit, these airplanes participated in one of America's first air races. The aviators were Arch Hoxsey and Calbraith Rodgers, two of the best known members of the country's first generation of pilots. (Bill Lehman collection.)

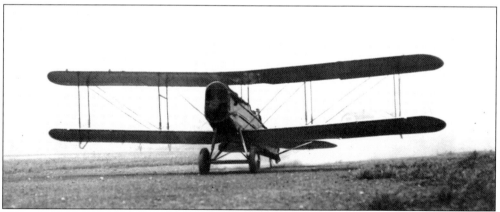

Taken in August 1923, this photograph shows an airmail DeHaviland DH-4 touching down at Martin Field on Cleveland's east side. The DeHaviland DH-4 was a World War I surplus bomber modified for airmail use by placing the pilot in the location of the former gunner's cockpit and converting the original pilot's cockpit into a mail bin. The airplane was powered by a 400-horsepower Liberty engine. (Cleveland Press Collection, Cleveland State University.)

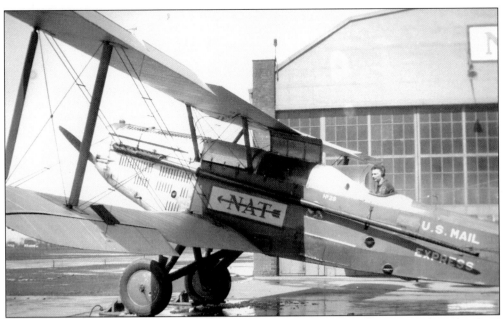

Chocked on the ramp in front of the National Air Transport hangar at the Cleveland Municipal Airport, this is a Douglas M-2 mail plane. This outstanding aircraft was one of the first generation of purpose-built mail planes designed to replace the weary, rebuilt, World War I–vintage DeHaviland DH-4s that dominated airmail flying through the mid-1920s. (Author's collection.)

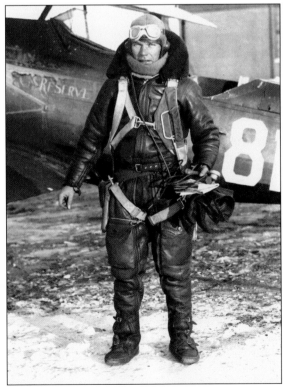

On a bleak winter day in March 1934, U.S. Army Air Corps pilot Lt. Howard A. Cheney prepares to head west toward Cleveland with a load of airmail. Airmail flights were normally handled by civilian contractors, but at this time they were on strike. In a rare misjudgment, Franklin D. Roosevelt ordered army pilots to take their places. The army pilots' lack of bad weather flying experience was soon made painfully obvious as many lost their lives trying to maintain mail service until the issue was resolved. Cheney's equipment includes a rare B-2 sheepskin flight jacket and a model 1911 Colt .45. The pistol was carried to protect the mail from robbers. He also carries a microphone, indicating that his aircraft is equipped with a radio. (Author's collection.)

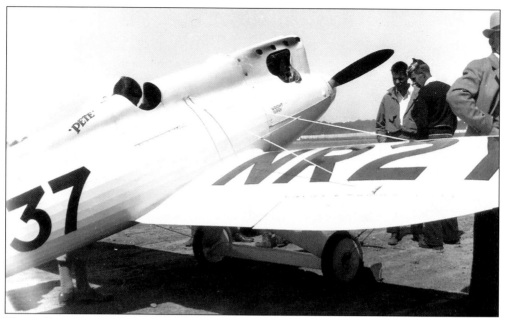

This is Benny Howard's first racing plane, the DGA-3 known as *Pete*. The airplane introduced several features that became Howard racer trademarks, such as small size, excellent workmanship, and the striking white overall paint scheme. (John Sunyak collection.)

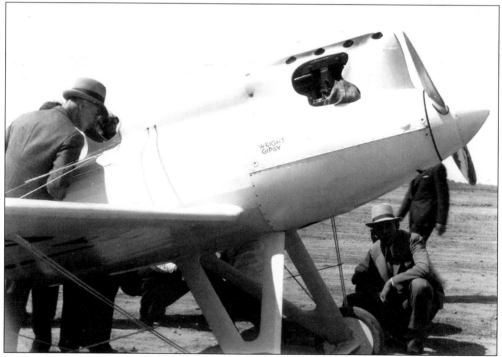

In this view, *Pete*'s small size is especially apparent. At a time when radial engines were the norm for racing planes, *Pete*'s four-cylinder, in-line Wright Gipsy engine was notable. The airplane survives today in the collection of the Crawford Auto-Aviation Museum. (John Sunyak collection.)

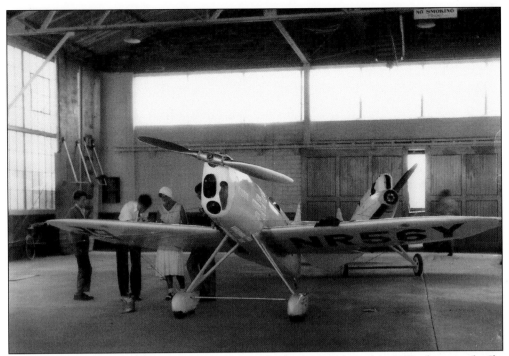

Howard's DGA-4, named *Ike*, relegates *Pete* to the background in this 1932 photograph. *Ike* was powered by a 489-cubic-inch Menasco Buccaneer six-cylinder engine. Today the airplane is owned by the author and his business partner Karl Engelskirger and is in the course of being restored to flying condition. (John Sunyak collection.)

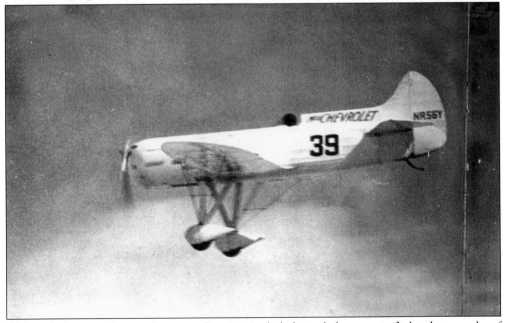

Although this snapshot is of poor quality, it is included simply because in-flight photographs of golden age racers are so rare. The airplane is the Howard DGA-4, *Ike*, seen here wearing the logo of its corporate sponsor, Chevrolet. (John Sunyak collection.)

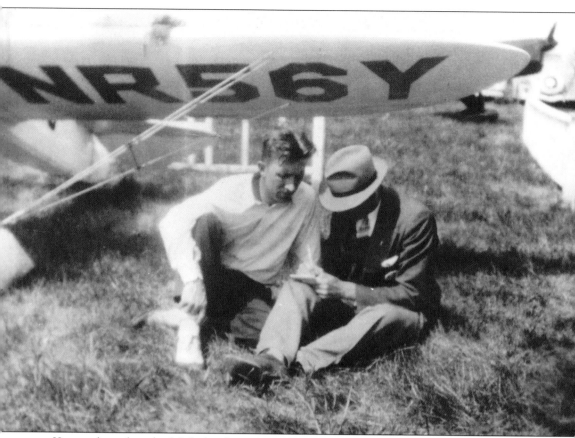

Known throughout his life for his down-to-earth approachability, Harold Neumann demonstrates that quality here, as he sits on the grass beneath the wing of a Howard DGA-4 to grant an interview. He would have been a good subject in 1935, the year his exceptional flying skills took him to first place in the Greve and Thompson Trophy Races at Cleveland while flying Howard aircraft. Benny Howard's Bendix race victory completed the sweep of events that year that led wags to refer to the outcome as the Benny Howard National Air Races. (John Sunyak collection.)

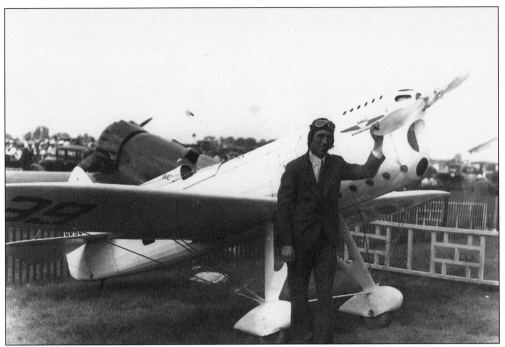

Neumann and *Ike* flew together frequently during air racing's golden age. They are seen together in the in the pit area where the racers were displayed between events at the Cleveland National Air Races. (John Sunyak collection.)

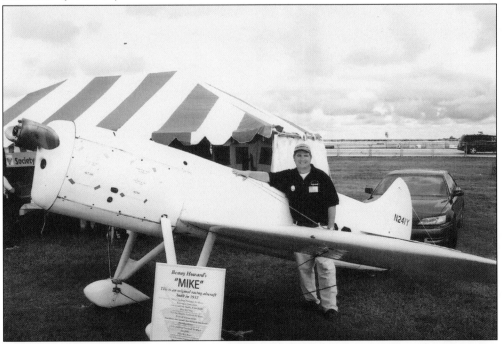

Neumann is long departed, but his racer *Mike*, the nearly identical twin of *Ike*, still exists, and is seen here with its co-owner Karl Engelskirger, very likely the only pilot who can look forward to the experience of flying a golden age racer. (Photograph by Adam Snelly.)

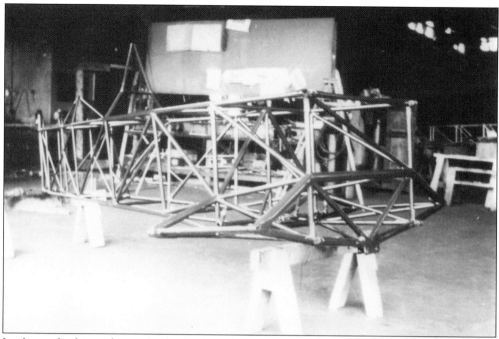

Looking aft, this is the steel tube fuselage framework of the Gee Bee R-1, ultimately flown to victory by Jimmy Doolittle in the 1932 Thompson Trophy Race. (John Sunyak collection.)

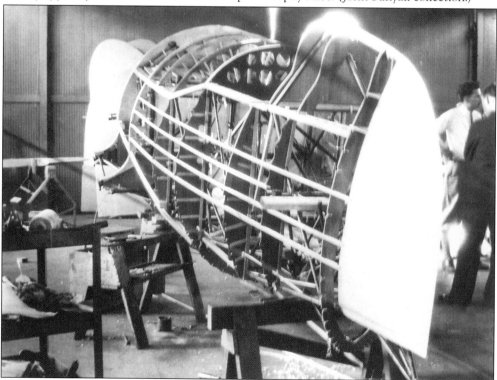

Farther along in the construction process, here the fuselage of the Gee Bee R-1 has its fairing strips installed and is nearly ready for cover. (John Sunyak collection.)

A study in raw power, this is the Pratt and Whitney engine installation in the Gee Bee R-1. The airplane's racing career would be brief. In the 1933 Bendix Trophy Race, Russell Boardman lost control during a take-off after a fuel stop in Indianapolis and died in the resulting crash. (John Sunyak collection.)

A rarely seen detail of the completed Gee Bee R-1, this is the cockpit entry door. A pilot with an active imagination must have wondered if escape was possible in the event of an emergency. (John Sunyak collection.)

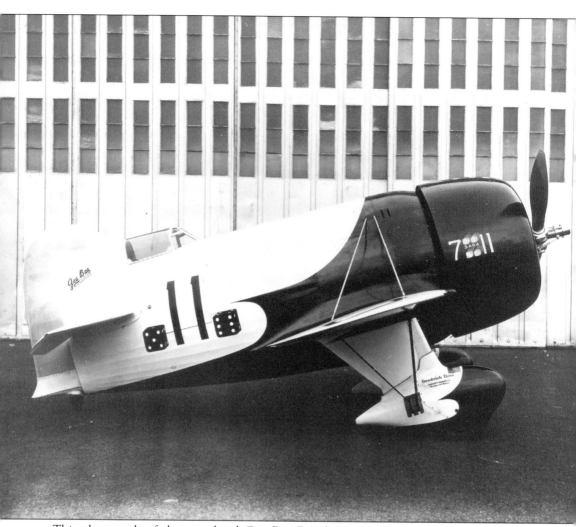

This photograph of the completed Gee Bee R-1 shows the outstanding workmanship that characterized so many of the hand-built racers of the 1930s. (John Sunyak collection.)

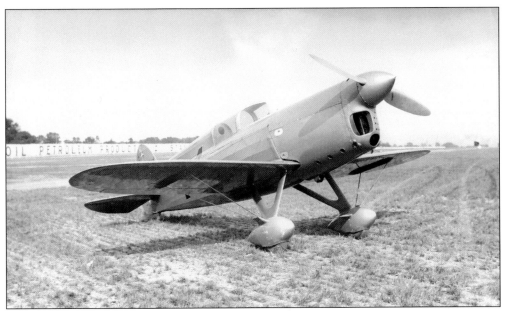

This is the Miles and Atwood Special flown so capably by Lee Miles. The vast cow pasturelike expanse of the Cleveland Municipal Airport extends far beyond this tiny green airplane. (John Sunyak collection.)

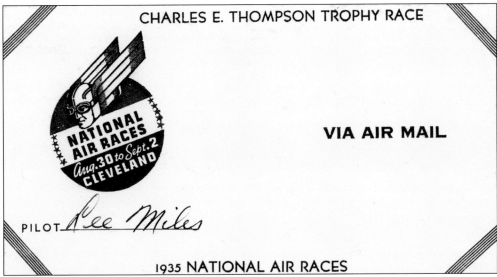

Autographed envelopes, like this one signed by Miles, were popular collectibles in the 1930s and remain so today. (Author's collection.)

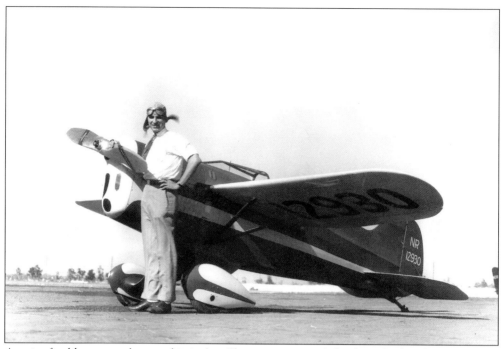

A pair of golden age stalwarts, this is Art Chester posing with his homebuilt pylon racer, *Jeep*. (John Sunyak collection.)

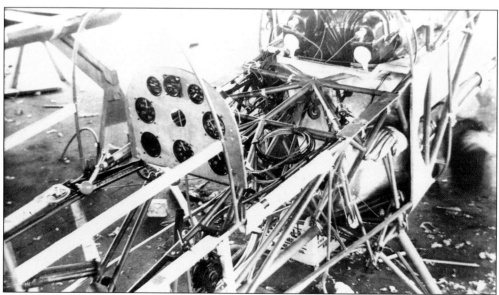

Another rare look at a one-of-a-kind golden age racer under construction, this airplane is the Folkerts SK-4. (John Sunyak collection.)

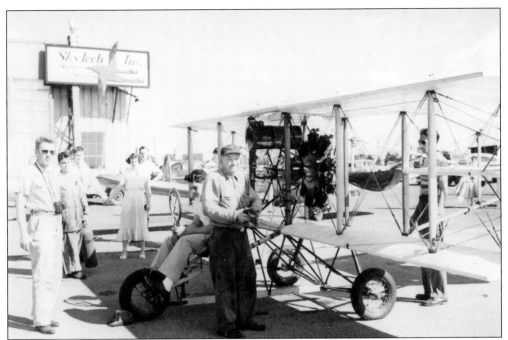

This is a Curtiss Pusher demonstrated at the 1946 Cleveland National Air Races. Not a replica, this is a restored original powered by a Gnome Rotary engine. The airplane was restored by Billy Parker, who began his aviation career as a mechanic for Glenn Curtiss. (Photograph by George K. Scott; author's collection.)

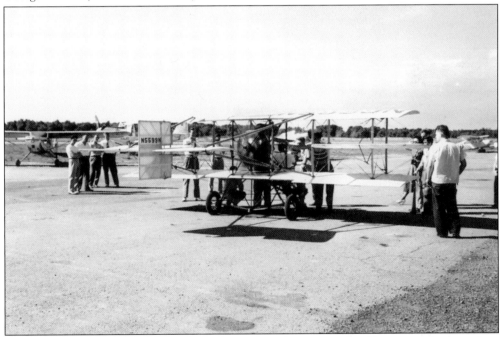

Here is a good view of Parker's Curtiss Pusher with its engine running. Demonstrating its unique operating principle, this view shows the rotary engine's cylinders and crankcase spinning around its stationary crankshaft. (Photograph by George K. Scott; author's collection.)

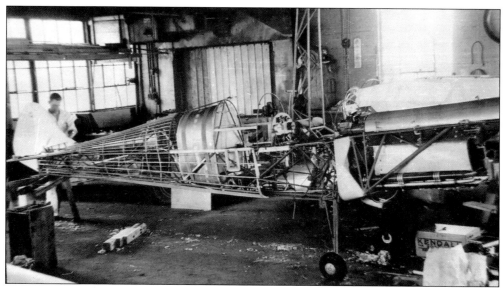

Here is another look at the Folkerts SK-4 taken while under construction. (John Sunyak collection.)

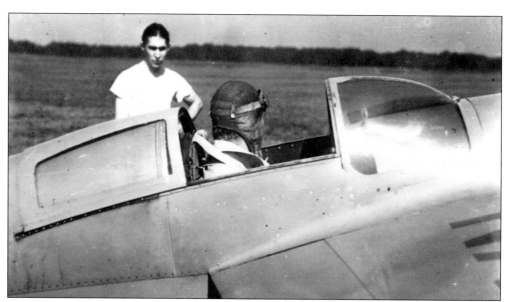

Golden age racers were built for speed, not comfort. Since pylon events were generally short, this was not seen as problem. The only creature comfort offered by the Folkerts SK-4 is the black tube on the glare shield to direct fresh air at the pilot. (John Sunyak collection.)

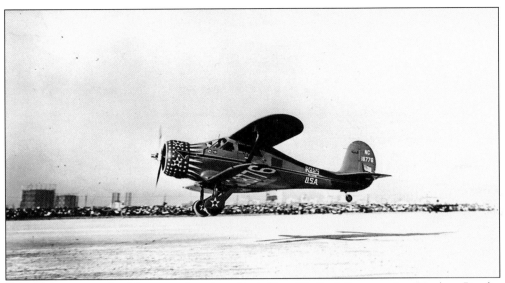

One of the most colorful racers of its day, this is Ross Hadley's Staggerwing Beech, a Bendix Trophy contender in 1938. (John Sunyak collection.)

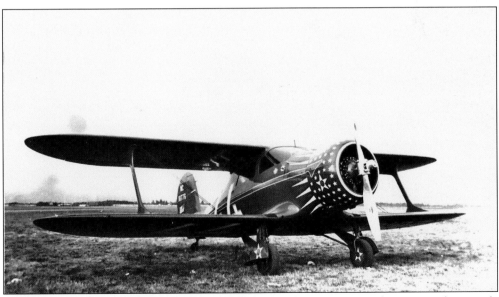

Hadley's Staggerwing Beech survived its racing days by many years, but was unfortunately destroyed in a crash at Amarillo, Texas, in the summer of 1976. (John Sunyak collection.)

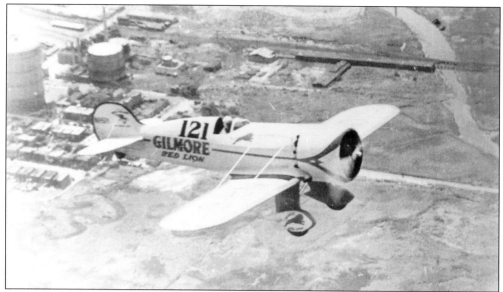

One of the best-known golden age racers, this is Roscoe Turner's Weddell-Williams. This airplane flew in the air races from 1932 until 1939 and may be seen today at the Crawford Auto-Aviation Museum in Cleveland. (John Sunyak collection.)

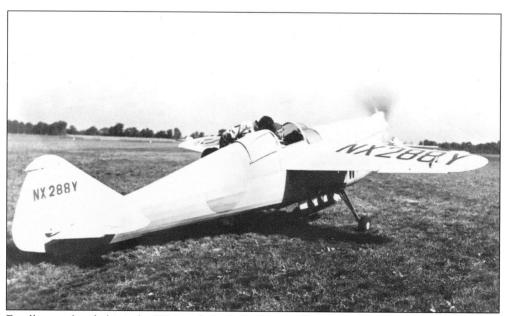

Finally completed, this is the SK-4 ready for flight. The airplane was star crossed. Nearly destroyed by wing flutter at Cleveland in 1938, the airplane survived only because of the extraordinary airmanship of pilot Roger Don Rae. One year later, Del Bush lost control while attempting a forced landing and crashed fatally. (John Sunyak collection.)

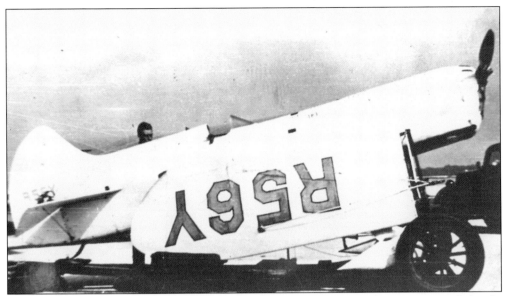

Most 1930s-era pylon racers did not have the fuel capacity for sustained cross-country flight. As a result, it was necessary to dismantle and trailer them from one event to another. The airplane is Benny Howard's DGA-4, *Ike*. (John Sunyak collection.)

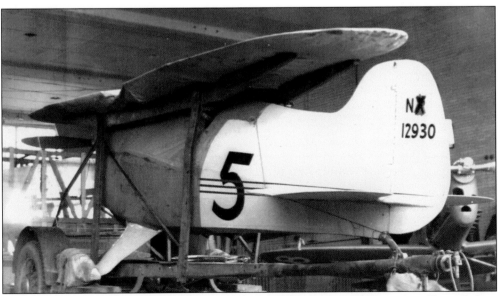

Taking a slightly different approach to the same problem, this airplane is Art Chester's *Jeep*, broken down for road transportation. (John Sunyak collection.)

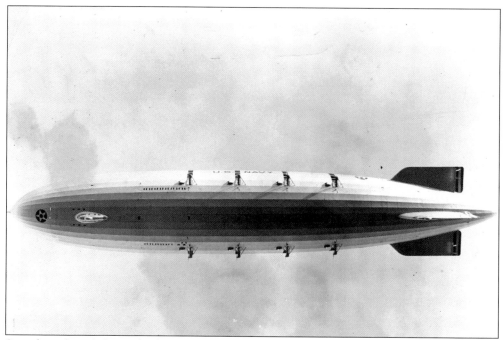

Seen from directly beneath, this is the brand new USS *Akron* rising into the air on its maiden flight in 1931. Not destined for a long life, the airship was lost with nearly all its crew just two years later. (Author's collection.)

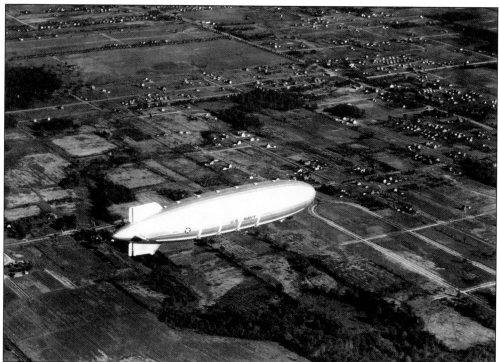

The USS *Akron* is seen here on a local test flight not far from the Goodyear airship hangar where it was constructed. (Author's collection.)

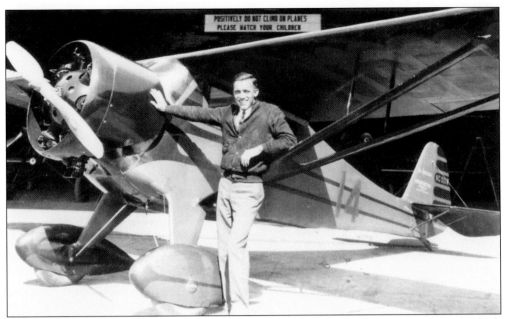

Originally powered by a 110-horsepower Warner engine, this clipped-wing Monocoupe was built for John Livingston in 1930. A very successful racer in its day, the type was also considered a demanding airplane to fly. This aircraft was destroyed in a fatal landing accident in July 1935. (John Sunyak collection.)

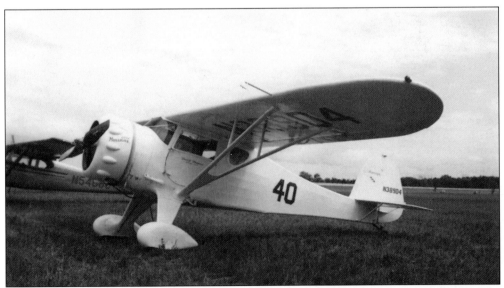

Harold Neumann never lost his passion for high performance flying. After his retirement from TWA, he purchased this Monocoupe, painted it in the color scheme of his 1935 Thompson Trophy winner Mister Mulligan, and flew it in aerobatic competition into the 1980s. In recognition of his great skill, he was inducted into the National Aerobatic Hall of Fame. (Author's collection.)

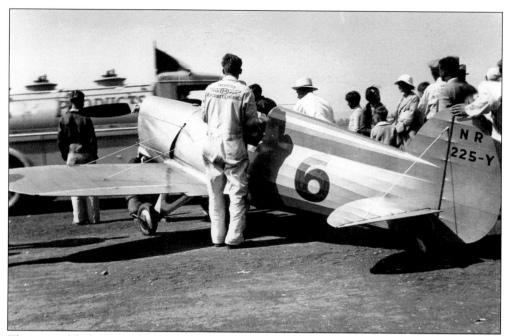

This view of the Miles and Atwood Special emphasizes the small size of a typical golden age pylon racer. The aircraft was lost as the result of a structural failure during time trials in Cleveland in 1937, taking the life of pilot Lee Miles. (John Sunyak collection.)

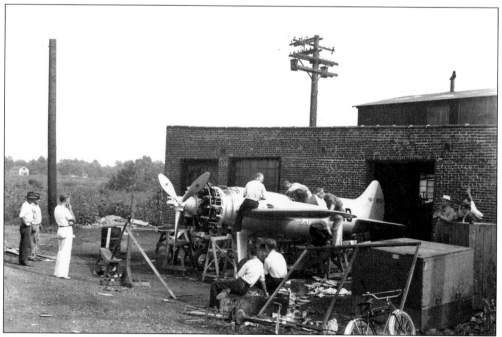

In this ramshackled outdoor setting, workers at Matty Laird's shop in Chicago put the finishing touches on Roscoe Turner's Laird-Turner Special. The clutter of the work area does not exactly inspire confidence. (John Sunyak collection.)

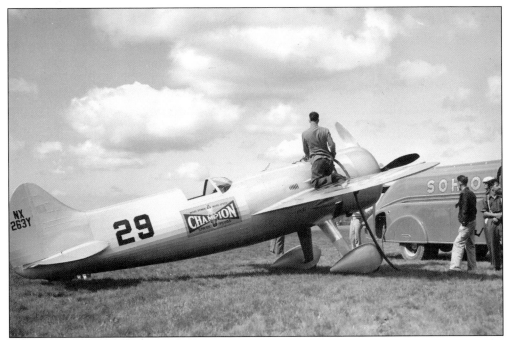

The workers in the previous photograph evidently knew what they were doing, for this was the result of their labor. Here Turner's aircraft is serviced just before the start of the 1939 Thompson Trophy Race. (John Sunyak collection.)

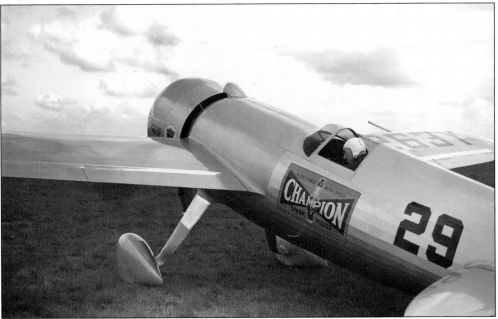

An uncharacteristically subdued Turner reflects for a moment on the starting line of the 1939 Thompson Trophy Race. Moments later, the flag dropped, and Turner flew into air racing history as the only three-time winner of the Thompson Trophy. It was the end of air racing's golden age. Turner never raced again, and World War II began in Europe even as this photograph was taken. (John Sunyak collection.)

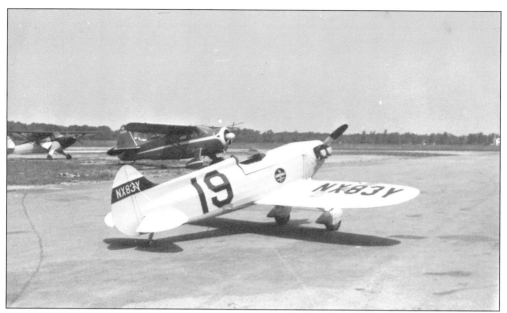

This is a rare example of a pre-war racer refurbished to take part in postwar events. This is the Brown B-1, originally constructed in 1934. Restored to its original configuration in the 1990s, the airplane still exists today. (Photograph by George K. Scott; author's collection.)

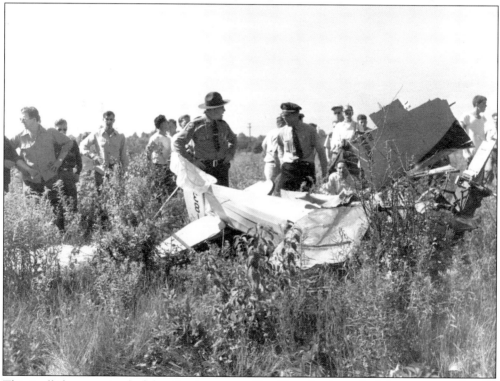

This is all that remained of the Goodyear racer *Estrellita* after it crashed during an air show at Cook Cleland's airport in Willoughby on September 4, 1950. Pilot Chester Black was killed. (Bill Lehman collection.)

Not something its designers envisaged, this is a 1918 vintage Curtiss Jenny, repowered with a World War II–era Ranger engine. The wing walker is a bit conservative compared to his 1920s counterparts, who did their routines without any sort of safety equipment. (Cleveland Press Collection, Cleveland State University.)

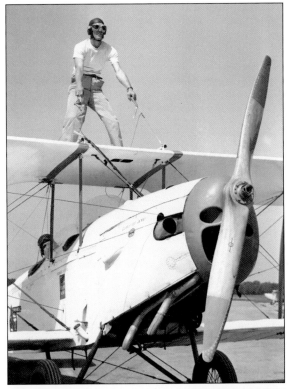

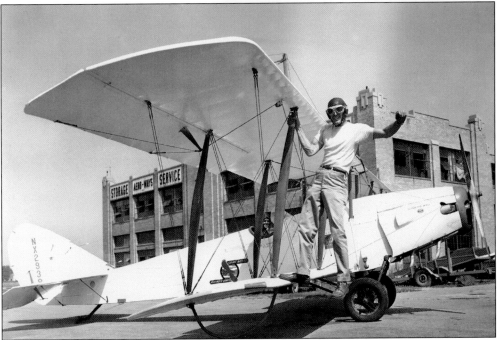

Here is a good overall view of the Ranger-powered Curtiss Jenny. It was operated by a traveling air show act called the Hollywood Hawks and was seen at the Cleveland National Air Races in 1947. (Cleveland Press Collection, Cleveland State University.)

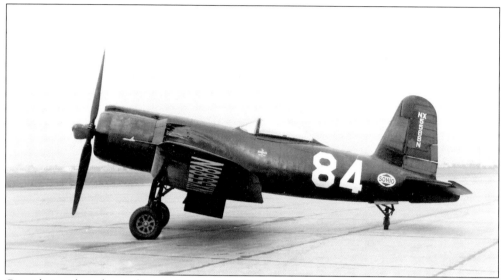

Considering their demanding performance and how infrequently they were flown, Cook Cleland and the pilots associated with him established a remarkable safety record competing with Super Corsairs in the postwar races. The aircraft shown here became the tragic exception. Race number 84 was flown in the 1947 Thompson Trophy Race by Tony Janazzo. Janazzo was naval reserve officer and had just completed pre-medical studies at John Carroll University. He was scheduled to begin medical school at Loyola University after the race. In the seventh lap, Janazzo missed a turn and began a shallow descent on a southbound heading. His aircraft impacted the ground at high speed and left a trail of debris a mile long at the crash site in Strongsville. (Adam Snelly collection.)

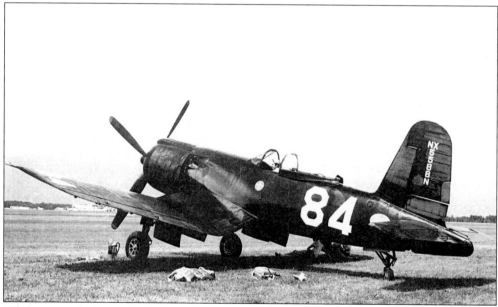

While some admirers seek shade under its wing, this candid photograph illustrates the shabby paint job applied to race number 84. Traces of its original military paint scheme are visible beneath its fresh coat of black paint, said to have been house paint applied with a roller. (Photograph by H. G. Martin; Kansas Aviation Museum, Robert J. Pickett collection.)

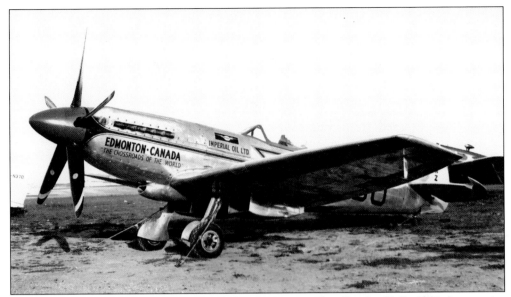

An unusual sight at the 1949 National Air Races was this Spitfire F. R. XIV. Its massive five-bladed propeller was turned by a Rolls-Royce Griffon engine. Flown by J. H. G. McArthur, it placed third in the Tinnerman Trophy Race with a speed of 359.565 miles per hour. (Adam Snelly collection.)

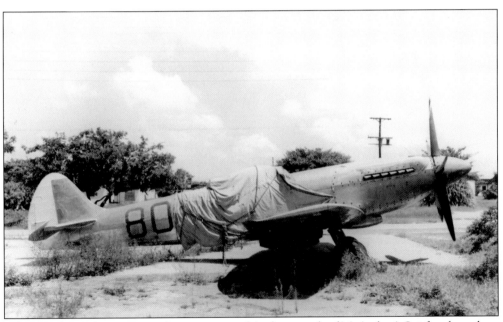

Taken not long after its racing days were over, this photograph of McArthur's Spitfire shows how quickly the postwar racers began their descent into derelict status. With jets poised to take over all truly high-performance applications, there was very little demand for the piston-engined aircraft that won the Second World War. (Adam Snelly collection.)

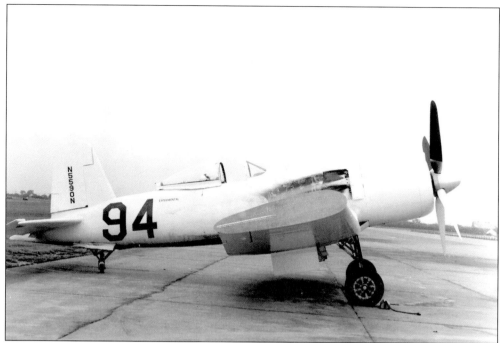

Having carried Cook Cleland to his second Thompson Trophy victory in 1949, his Super Corsair was parked on the ramp at Cleveland to await a very uncertain future. (Photograph by H. G. Martin; Kansas Aviation Museum, Robert J. Pickett collection.)

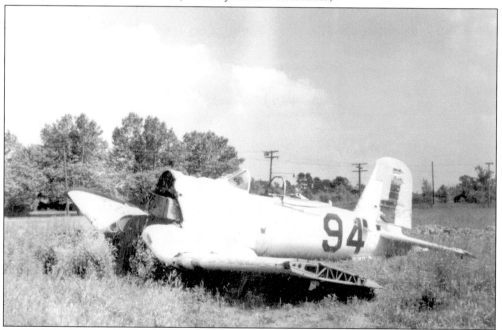

Remember, all glory is fleeting. Taken in the summer of 1956, this photograph documents the sad end of an extraordinary airplane that really deserved a better fate. Shortly after this photograph was taken, what remained of Cleland's 1949 Thompson Trophy winner was burned, bulldozed, and buried in a remote corner of Cleveland Hopkins Airport. (Adam Snelly collection.)

Dick Becker was probably the most well-rounded and experienced pilot to participate in the postwar races. He flew a Super Corsair to second place in the 1947 Thompson Trophy Race. In 1948 and 1949, mechanical problems kept him from finishing. He would have been a top competitor armed with a truly reliable airplane; it causes one to wonder, what if? (Cleveland Press Collection, Cleveland State University.)

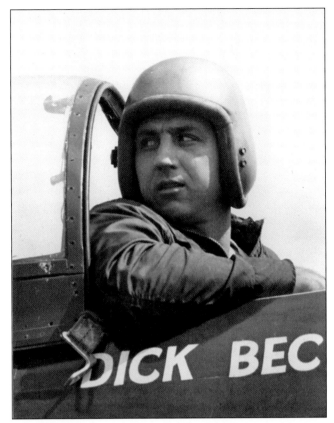

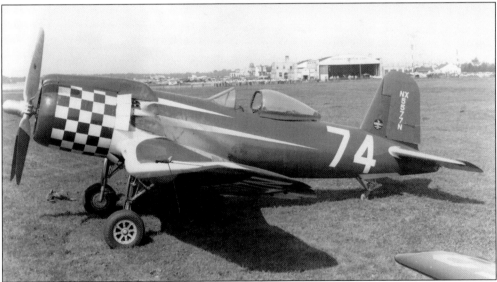

This F2G-1 Super Corsair was closely associated with both Becker and Cleland, Cleland flew it to victory in the 1947 Thompson Trophy Race. Subsequently Becker flew the airplane in 1948 and 1949. Both times mechanical problems kept him from his rightful place among the finishers. Saved from destruction by Walter Soplata, the airplane is currently being restored on behalf of a new owner. (Adam Snelly collection.)

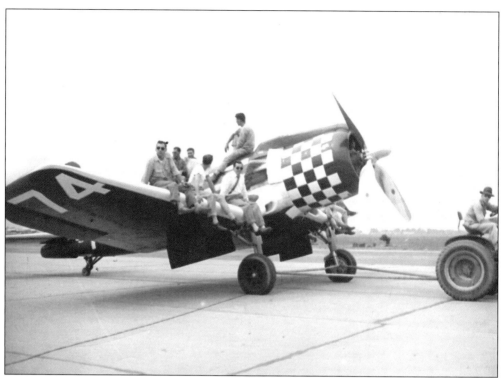

Dick Becker's Super Corsair carries a crowd of admirers as a tractor tows it on the ramp at Cleveland. (Cleveland Press Collection, Cleveland State University.)

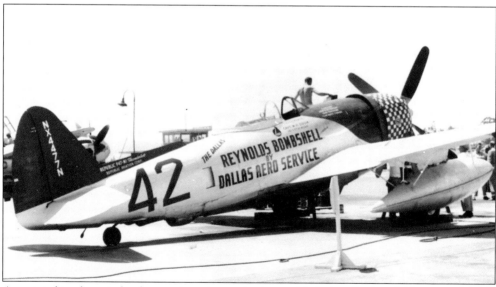

Associated in the minds of most air racing enthusiasts with Jackie Cochran's *Beguine*, of tragic memory, Bill Odom was scheduled to fly this Republic P-47M in the 1947 Bendix Trophy Race, an event that probably would have been a much better match for his skills than pylon racing. This will never be known, since a massive fuel leak rendered the airplane unflyable shortly before the race was scheduled to start. (Adam Snelly collection.)

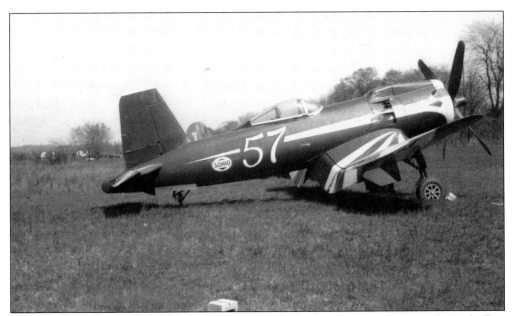

Photographed at Cook Cleland's airport in Willoughby, this airplane was flown to victory by Ben McKillen in the 1949 Tinnerman Trophy Race. After many years of neglect and indifference, it has been beautifully restored by Bob Odegaard. It is the only one of Cleland's Super Corsairs to remain airworthy. (Bill Lehman collection.)

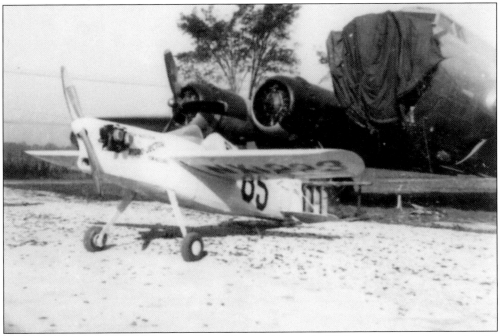

Posing with a damaged B-17 at the Lost Nation Airport in Willoughby, the airplane in the foreground is the Goodyear racer *Hurlburt Hurricane*. Built for local pilot Marge Hurlburt, a dilemma arose when a check of the rules showed that women were barred from competing in the race. The question was rendered moot by Hurlburt's death while performing at an air show on July 4, 1947. (Bill Lehman collection.)

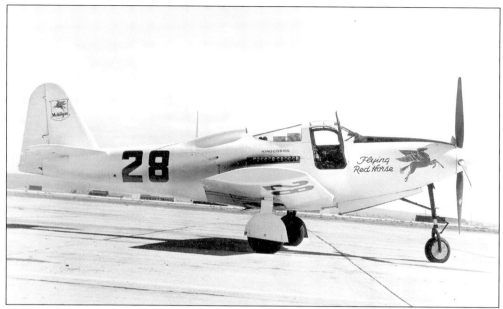

Flown in the 1946 Thompson Trophy Race by owner Charles Tucker, this modified Bell P-63C was named *Flying Red Horse*. The thickness of the wing at the tip is evidence of the drastic shortening of the wingspan in an effort to achieve more speed. (Photograph by H. G. Martin; Kansas Aviation Museum, Robert J. Pickett collection.)

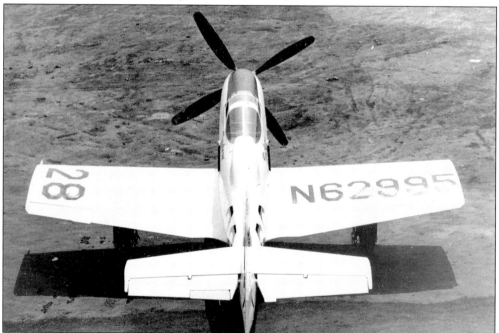

Seen from this angle, the radical structural modification to Charles Tucker's race number 28, *Flying Red Horse*, is much more apparent. Tucker dropped out of the 1946 Thompson Trophy Race quickly with a landing gear problem, but one is left to wonder about the adverse effect on the aircraft's handling caused by the drastic reduction in wing area. (Photograph by Charles Tucker; Adam Snelly collection.)

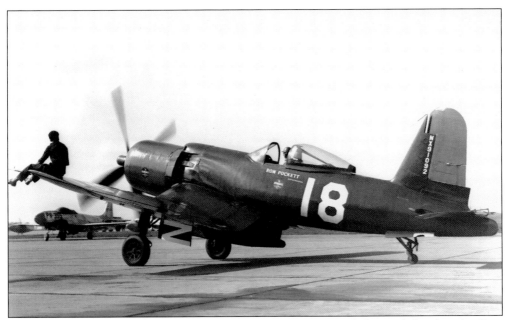

With the stick well aft and a mechanic perched on the wingtip to help watch for obstacles, Ron Puckett taxies his F2G-1 Super Corsair *Miss Port Columbus* during the 1947 National Air Races. Puckett got a late start in that year's Thompson Trophy Race, yet still managed to work his up to fourth place before engine trouble forced him out. (Photograph by H. G. Martin; Kansas Aviation Museum, Robert J. Pickett collection.)

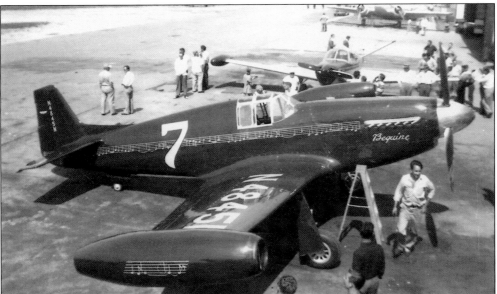

One of the most controversial of the postwar racers, this is the radically modified P-51-C owned by Jackie Cochran. Named *Beguine*, the belly radiator and scoop were removed, and new radiators were installed in the wingtips. Potentially the fastest Mustang ever built, its racing career came to an abrupt end when pilot Bill Odom lost control of the aircraft during the 1949 Thompson Trophy Race. The airplane plunged into a house on West Street in Berea, killing a mother and child, as well as Odom. (Adam Snelly, Sid Bradd collection.)

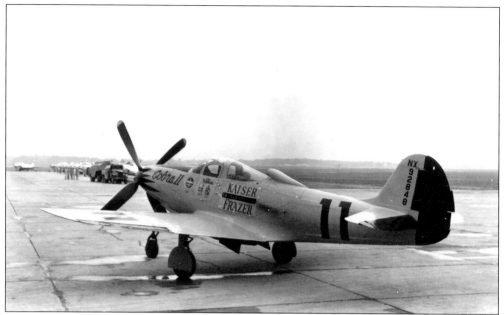

Flown by Tex Johnston, this modified Bell P-39Q won the 1946 Thompson Trophy Race. The airplane achieved a speed in excess of 400 miles per hour in time trials. Finishing in the money in 1947, the aircraft dropped out of the 1948 Thompson Trophy Race after experiencing engine trouble. Extensively modified 20 years later to participate in unlimited racing, the airplane crashed in the course of its first test flight, killing pilot Mike Carroll. (Photograph by H. G. Martin; Kansas Aviation Museum, Robert J. Pickett collection.)

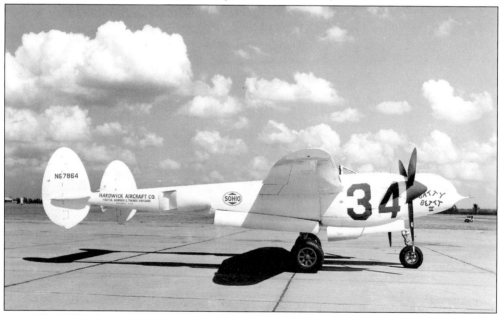

A modified F5G, this aircraft was flown in 1948 and 1949 by Jack Hardwick. Modifications to the aircraft were subtle and consisted of the removal of the stabilizer tips and the turbochargers. The airplane finished fourth in the 1949 Tinnerman Trophy race, clocked at 328.470 miles per hour. (Photograph by H. G. Martin; Kansas Aviation Museum, Robert J. Pickett collection.)

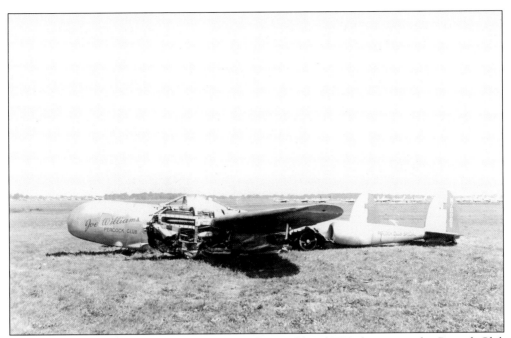

A veteran of several of the postwar air races, this Lockheed F5G, known as the *Peacock Club Special* found itself in this predicament when pilot Jack Becker experienced an in-flight fire and made a forced landing during time trials for the 1949 National Air Races. (Photograph by H. G. Martin; Kansas Aviation Museum, Robert J. Pickett collection.)

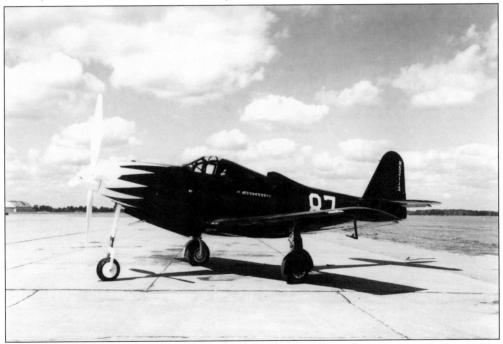

Named *Kismet*, this Bell P-63C King Cobra competed in the National Air Races in 1947 and 1949, flown by its owner, A. T. Whiteside. Its striking color scheme was black and white. (Photograph by H. G. Martin; Kansas Aviation Museum, Robert J. Pickett collection.)

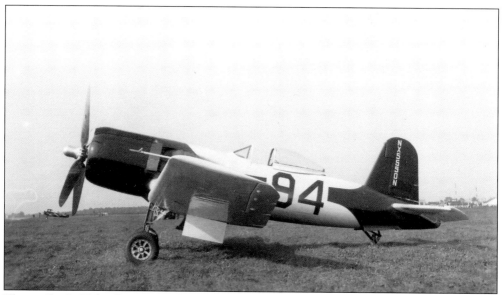

This is Cook Cleland's renowned F2G-1 number 94 as it appeared in the 1947 National Air Races when Dick Becker flew it to second place in the Thompson Trophy Race, attaining a speed of 390.133 miles per hour. (Photograph by H. G. Martin; Kansas Aviation Museum, Robert J. Pickett collection.)

This program from the first annual banquet of the Western Reserve Aviation Hall of Fame bears the signatures of several great figures in Cleveland's aviation history. (Author's collection.)

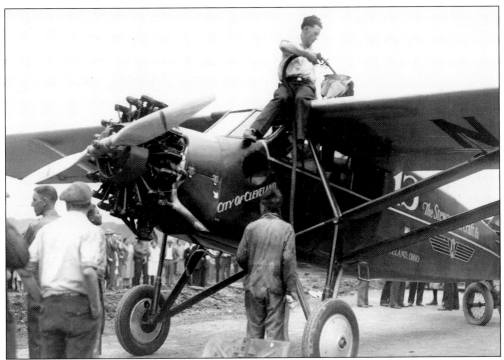

This Stinson Detroiter was being prepped for an attempt on an endurance record when this photograph was taken in the summer of 1929. Due to concerns about fuel contamination, a common practice in the 1920s was to strain gasoline through a chamois, and that is what the mechanic seen here is doing. (Cleveland Press Collection, Cleveland State University.)

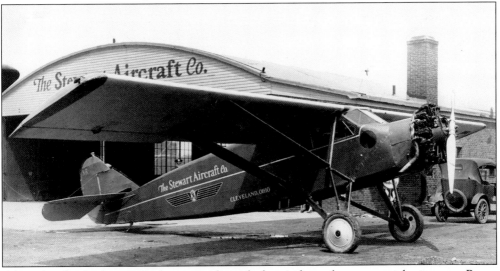

After a brief setback, an initial attempt aborted after six hours by a torrential rainstorm, Byron Newcomb and Roy Mitchell met their goal and set a new endurance record on their second try. While the pilots were hailed as heroes, an unruly crowd of souvenir hunters nearly demolished their airplane when they landed. Their presence on the front pages was destined to be short lived. Just four days after they landed, their newly set record was broken, and Newcomb and Mitchell began their retreat to obscurity. (Cleveland Press Collection, Cleveland State University.)

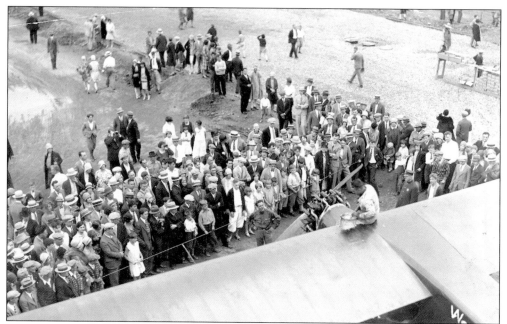

Probably taken from a hangar roof, this picture emphasizes the large size of the Stinson Detroiter as a mechanic fuels the airplane in preparation for its record attempt. (Cleveland Press Collection, Cleveland State University.)

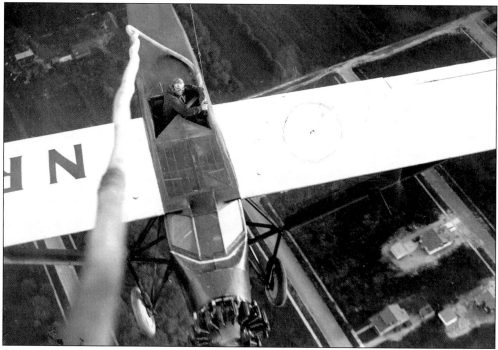

The refueling process as seen from the supply plane is shown here. With nothing in the way of safety equipment, and standing upright in the 100-mile-per-hour slipstream, one of the crew strains to reach the refueling hose that permitted the flight to continue. (Cleveland Press Collection, Cleveland State University.)

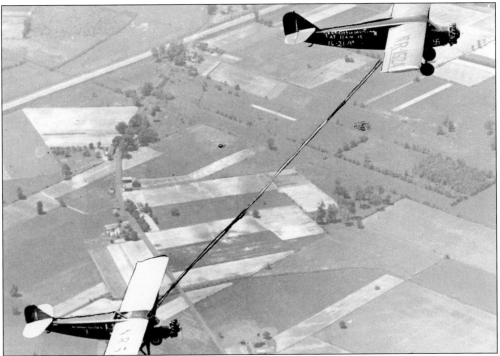

With their record attempt in progress, the Stinson Detroiter flown by Bryon Newcomb and Roy Mitchell is seen here being refueled in the air, a process that had to be repeated a number of times during their 174-hour-long flight. Their aircraft covered a distance the equivalent of 14,500 miles and consumed 1,914 gallons of gasoline during the hours they spent circling the city. (Cleveland Press Collection, Cleveland State University.)

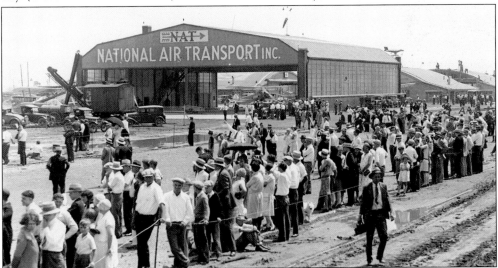

Flying constantly from June 29 to July 6, 1929, Newcomb and Mitchell set a new endurance record in the skies over Cleveland. This is part of the crowd that watched them do it. Construction equipment makes clear that finishing touches are being applied to get the airport ready for the National Air Races, scheduled to begin less than a month later. (Cleveland Press Collection, Cleveland State University.)

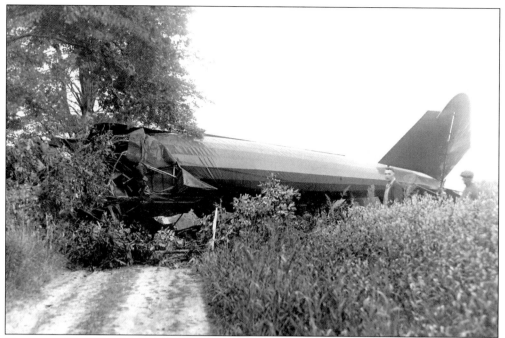

On August 29, 1929, pilot Jack Reid took off alone from the Cleveland Municipal Airport to try to break a solo endurance flying record. Flying into the next day, he broke the previous record of 38 hours. Shortly afterward, he crashed to his death, having apparently fallen asleep at the controls. Married for just one day, the flight's sponsor had promised him a $100 bonus for each hour he flew beyond the old record. (Cleveland Press Collection, Cleveland State University.)

Taken in the summer of 1928, this view shows Kenneth Cole's airport, active from 1925 to 1935. The intersection of Mayfield Road and Ford Road is visible right center, with Brainard Road in the middle distance. Covered with houses since the late 1940s, no trace of the airport exists. (Author's collection.)

Three

CLEVELAND AREA AIRPORTS, PAST AND PRESENT

Cleveland's first airport was a strip of damp sand, just yards from the edge of Lake Erie. Permanent facilities did not arrive until some years later, and some of the area's oldest airports remain in operation today. When airports were established in the 1920s, relatively little effort was required. Wooden hangars were built, a windsock was set up, and they were open for business. Airplanes did not have brakes until much later, relying on tail skids to bring them to a stop, a method that worked very well on the sod fields of the day. Hard-surfaced runways did not come along until the 1930s when airplanes began to grow in size and weight. Cleveland's principal airport was known originally as the Cleveland Municipal Airport. Its name was not changed to Cleveland Hopkins International Airport until the 1950s.

Along the way, it saw a lot of innovations. Its original control tower was the first such facility in the country, and the airport was for many years the largest flying field in the world.

Many other airports have operated in the Cleveland area over the years providing area pilots with a wide range of choices and opportunities.

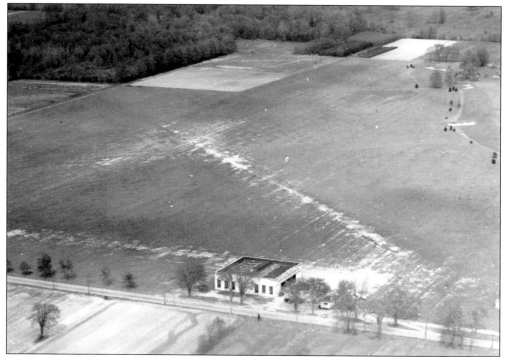

One of the oldest public-use airports in Ohio, Lost Nation Airport in Willoughby was established in 1929. Taken in May 1938, this photograph looks to the northeast and shows Lost Nation Road in the foreground. (Cleveland Press Collection, Cleveland State University.)

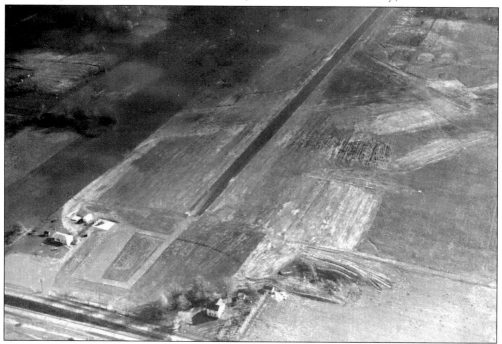

With Route 18 in the foreground and the east-west runway yet to be built, this is the Medina Airport as it appeared in 1957. (Eric Olson collection.)

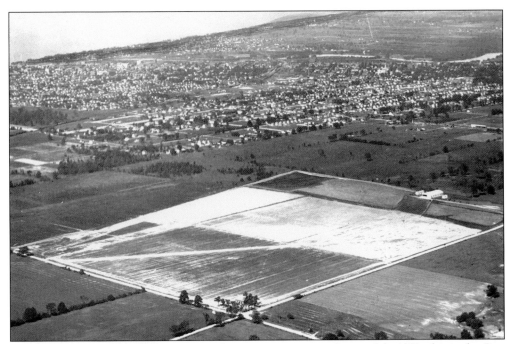

A prime example of a modern airport when its picture was taken in July 1929, this is the Port Mills Airport in Lorain, just west of Cleveland. The absence of hard surface runways is typical. Airplanes with tail skids and no brakes did not need them. (Cleveland Press Collection, Cleveland State University.)

The Akron-Canton Airport was still practically brand new when this picture was taken in June 1948. (Cleveland Press Collection, Cleveland State University.)

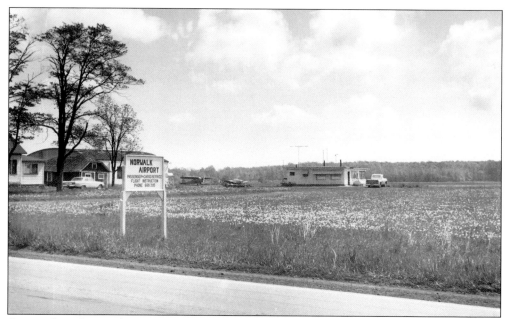

A typical rural general aviation airport of its day, this is the Norwalk Airport on a bright spring day in May 1961. (Cleveland Press Collection, Cleveland State University.)

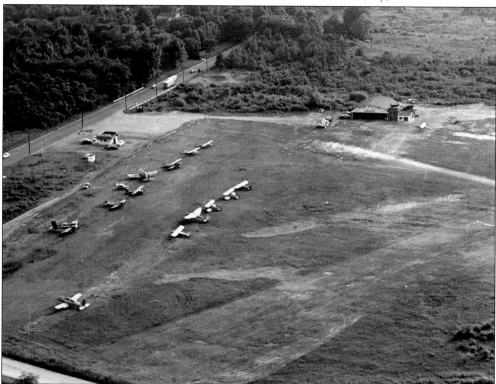

Looking west with Route 20 visible in the upper left, this is Cook Cleland's airport in Willoughby in the summer of 1950. The two Super Corsairs parked on the grass make it easy to recognize. (Bill Lehman collection.)

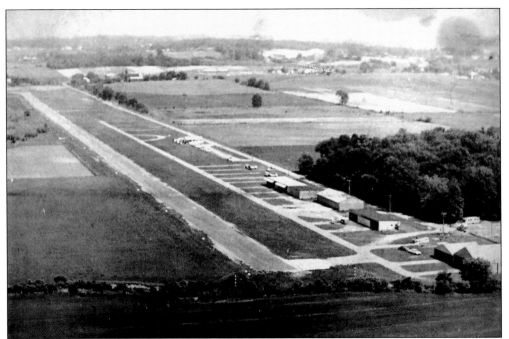

Looking east, this is the Wadsworth Airport as it looked in the summer of 1954. (Pete Engelskirger collection.)

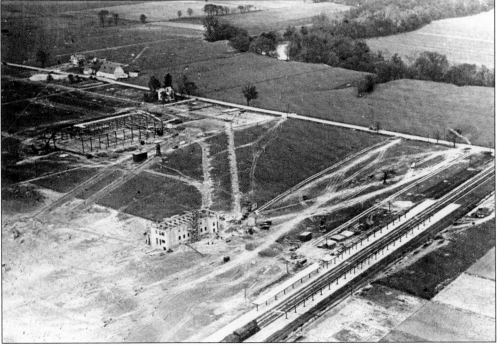

Taken at the Port Columbus Airport in May 1929, this photograph shows an ambitious construction project uniting air and rail passenger service. In that era, airliners did not fly at night. Trains took passengers through the night to other airports hundreds of miles away where airline travel could resume the next day. (Cleveland Press Collection, Cleveland State University.)

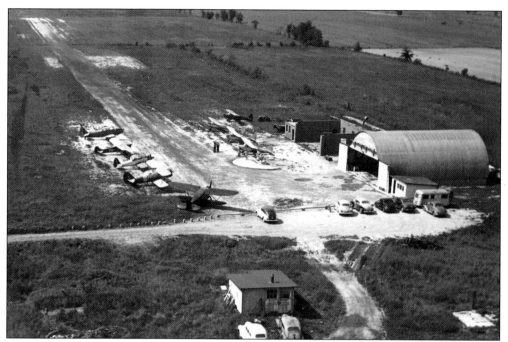

A typical Cleveland-area airport of the late 1940s was the Strauss Airport, once located at the intersection of Cook and Lorain Roads in North Olmsted. Recognizable aircraft include a Cabin Waco, an N3N, a Stearman, a Ryan PT-22, a Fairchild PT-19, and an assortment of Cubs and Champs. (Cleveland Press Collection, Cleveland State University.)

Dated June 1939, this rendering shows a design proposed by the Civil Aeronautics Authority for a seaplane base to be constructed at Cleveland's lakefront. (Cleveland Press Collection, Cleveland State University.)

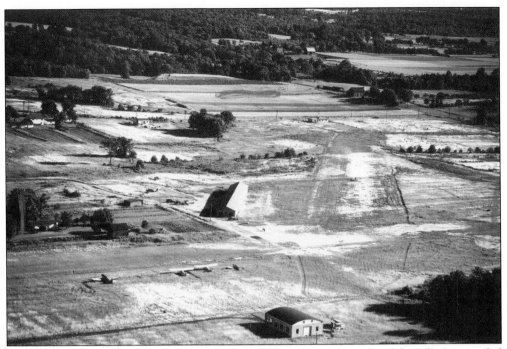

Looking to the southwest, this is the Strongsville Airport as it appeared in July 1953. Surrounded by new construction, the hangar in the foreground still exists. The rest of the former airport is covered with houses. (Cleveland Press Collection, Cleveland State University.)

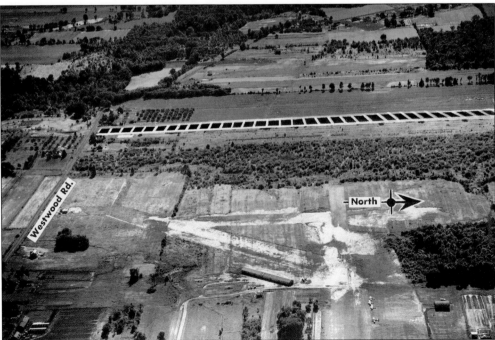

The Strongsville Airport, once located on the west side of Prospect Road near the intersection with Westwood Drive, was active from 1946 until the late 1980s. Sold to developers, the land is now a housing development. (Cleveland Press Collection, Cleveland State University.)

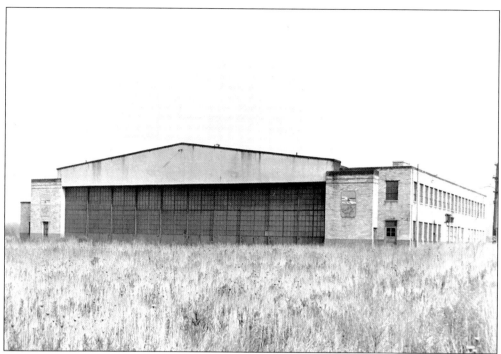

Constructed in 1929, this hangar was the focal point of the new Herrick Airport on Cleveland's east side. The airport was closed by an injunction shortly after it opened, and this how the hangar looked in 1945, after 15 years of inactivity. (Cleveland Press Collection, Cleveland State University.)

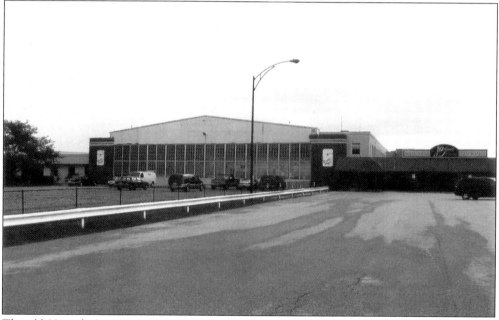

The old Herrick Airport eventually became the Cuyahoga County Airport, and the original structure returned to its intended use as an airplane hangar. It remains in daily use today as seen here in September 2007. (Photograph by Thomas G. Matowitz Jr.)

Relations with airport neighbors are sometimes tense, but this child on a picket line during a protest regarding the Cuyahoga County Airport seems more an appeal to emotions than to reason. The picture was taken in September 1952. (Cleveland Press Collection, Cleveland State University.)

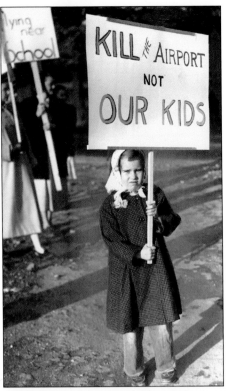

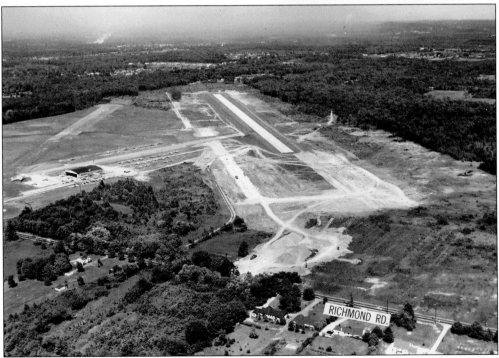

Supporters of the airport prevailed, making way for the expansion seen here in May 1962. (Cleveland Press Collection, Cleveland State University.)

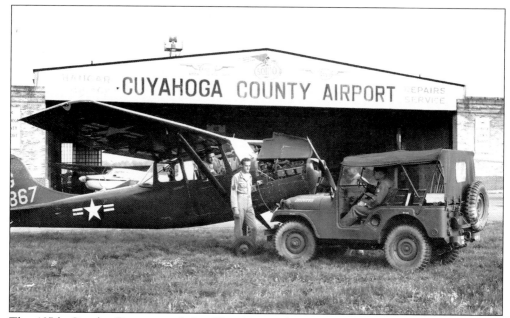

The 107th Cavalry Regiment of the Ohio National Guard operated these Cessna L-19s at the Cuyahoga County Airport in the mid-1950s. (Cleveland Press Collection, Cleveland State University.)

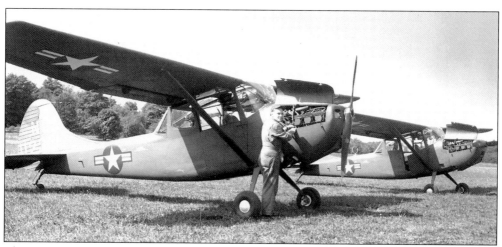

These L-19s undergo light maintenance on a summer day in the 1950s. A modern light plane design, the L-19s were replacements for the tube-and-fabric L-4s and L-5s of World War II days. (Cleveland Press Collection, Cleveland State University.)

Seen from the left seat of an early Stinson, this photograph from the fall of 1927 shows the north end of the hangar line at the Cleveland Municipal Airport. (Cleveland Press Collection, Cleveland State University.)

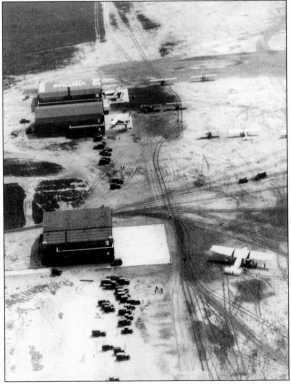

In August 1929, the Cleveland Municipal Airport prepared to host the National Air Races for the first time. Scheduled airline service was already in progress, as shown by the Ford Tri-motor loading passengers in the foreground. (Cleveland Press Collection, Cleveland State University.)

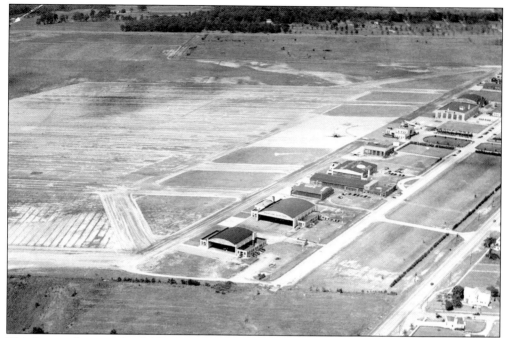

This hangar line on the field's east edge was a Cleveland Municipal Airport trademark from the late 1920s until the early 1950s when airport renovations swept it away. While it is entirely possible that the DC-3 on the ramp still exists, nearly everything else seen here is gone. (Cleveland Press Collection, Cleveland State University.)

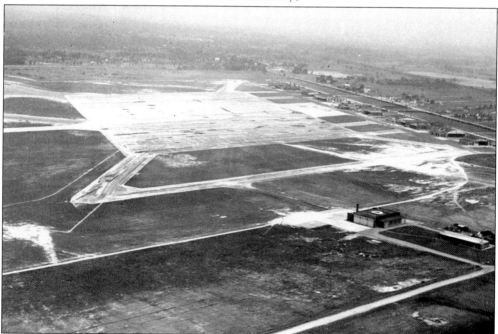

Looking to the northeast, this view shows the completed paving project undertaken at the Cleveland Municipal Airport in 1938. Comprising 85 acres, it was said to be the largest paved surface in the world. (Cleveland Press Collection, Cleveland State University.)

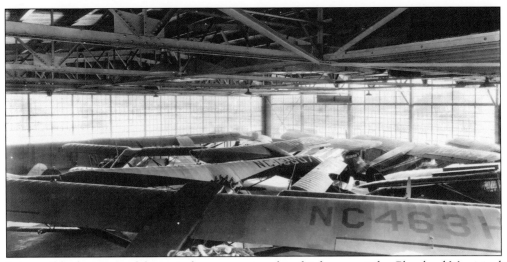

It is possible that some of these airplanes were stored in this hangar at the Cleveland Municipal Airport because of poor economic conditions during the depression. It certainly is a hangar full. Identifiable airplanes include Wacos, Stinsons, and Fleets. (Author's collection.)

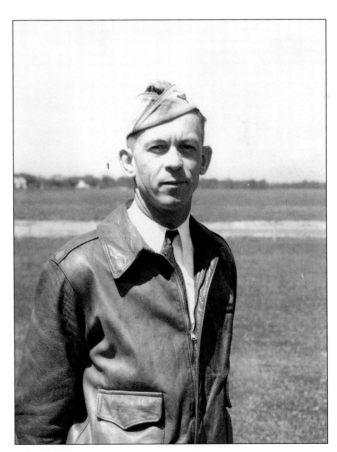

Seen here as a reserve officer in the U.S. Army Air Corps in the late 1930s, Clarence Barnhill had a notable aviation career. At the start of the World War I, he worked his way to Europe on a cattle boat, arriving early enough to learn to fly in a Maurice Farman Shorthorn. The war's end found him flying Caproni triplanes in Italy. He returned to Cleveland and was employed in the local aviation industry for the rest of his life. Having been among the first military pilots of World War I, he lived to be numbered among their last survivors, dying in the early 1980s at the age of 89. (Author's collection.)

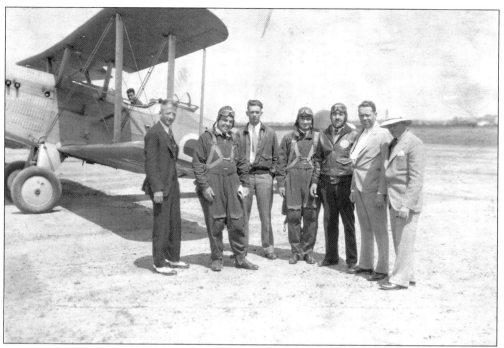

Some early pilots and aircraft from the 112th Observation Squadron are shown here in the late 1920s. The parachutes had been required for several years, but the A-1 leather flight jackets were new equipment adopted in 1926. (Author's collection.)

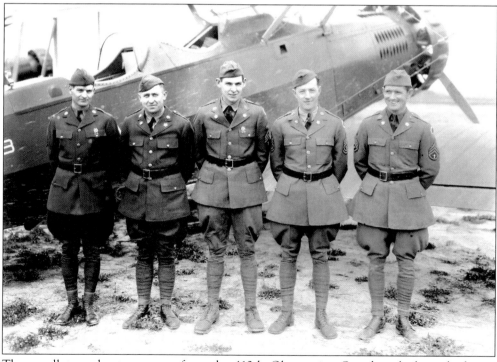

These well turned-out sergeants from the 112th Observation Squadron look ready for an inspection. The aircraft behind them is one of the unit's Douglas O-38s. (Author's collection.)

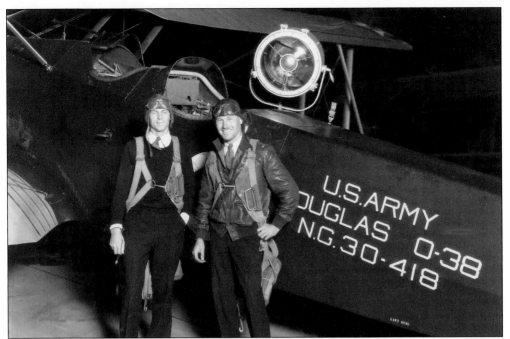

These men from the 112th Observation Squadron show details of the typical equipment of pilots in the 1930s. The A-1 flight jacket worn by the pilot on the right was issued from 1926 to 1931 and would have considerable value for collectors today. (Author's collection.)

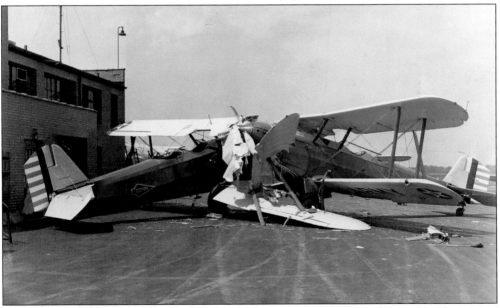

Visibility from tail-wheel aircraft on the ground can be poor, but it is certain that the pilot of the aircraft on the right had a very uncomfortable discussion with his commanding officer in the aftermath of this ground incident. It probably helped his case that the condition of the wreckage suggests that no one was injured. The arrowhead on the fuselage of the left-hand airplane indicates that it was assigned to Wright Field in Dayton, today's Wright Patterson Air Force Base. (Author's collection.)

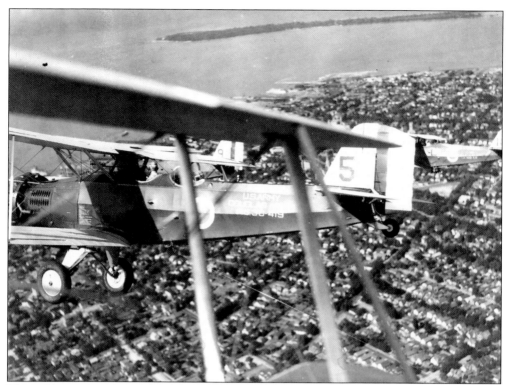

These Ohio National Guard Douglas O-38s based in Cleveland are seen on a training flight near Sandusky. (Author's collection.)

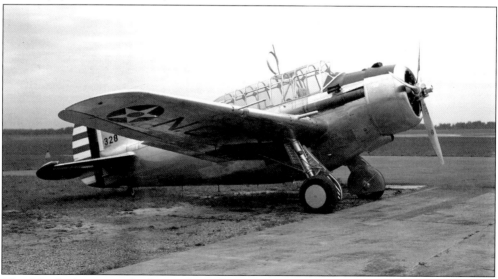

This North American O-47 was flown by the 112th Observation Squadron based at the Cleveland Municipal Airport when it was photographed in August 1938. Designed to meet an obsolete requirement, this aircraft was not a raging success, but it makes an interesting comparison with North American Aviation's renowned aircraft designs of just a few years later, the P-51 Mustang and the B-25 Mitchell, two of World War II's most significant combat aircraft. (Author's collection.)

When the old National Guard hangar was demolished to make way for the wartime bomber plant, this new structure was built to take its place. The unit occupying it was known as the 112th Bombardment Squadron (Light) when this photograph was taken shortly after World War II. The aircraft parked in the background are Douglas B-26 Invaders. The building remains in daily use as the I-X Jet Center. (Cleveland Press Collection, Cleveland State University.)

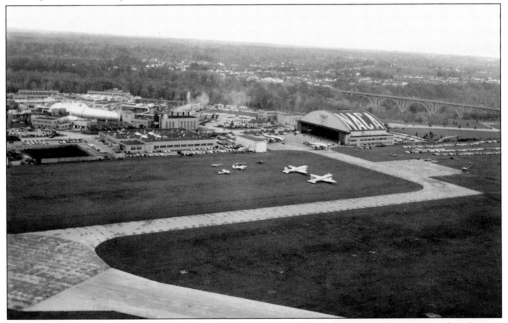

Before the National Air and Space Administration existed, there was the National Advisory Committee on Aeronautics. This was their facility at the Cleveland Airport in 1954. (Cleveland Press Collection, Cleveland State University.)

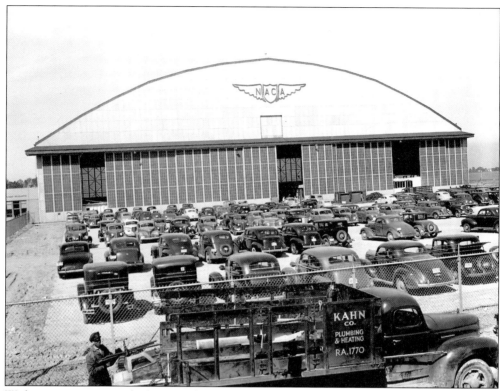

With its construction rushed to completion because of World War II, this is the new NACA Flight Research Hangar in May 1942. (Cleveland Press Collection, Cleveland State University.)

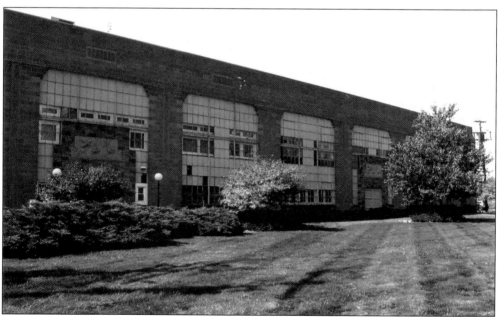

Once the United Airlines hangar at the Cleveland Municipal Airport, this large building was dismantled and moved to Chardon in 1951. (Photograph by Thomas G. Matowitz Jr.)

A walk around to the building's west side makes its origin as an aircraft hangar obvious. (Photograph by Thomas G. Matowitz Jr.)

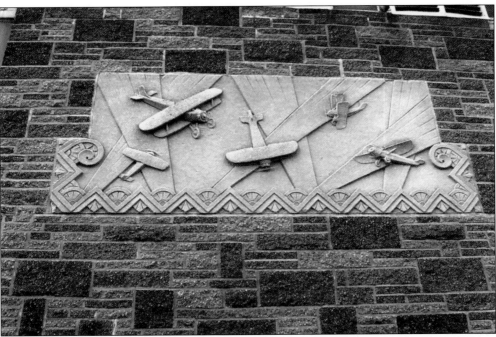

This art deco bas-relief from 1929 still adorns the flank of what was once the United Airlines hangar at the Cleveland Municipal Airport. (Photograph by Thomas G. Matowitz Jr.)

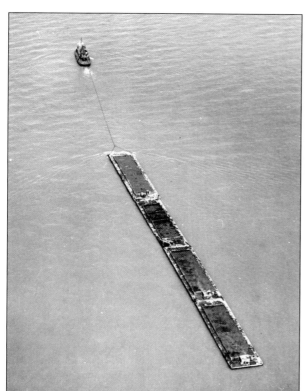

In what was certainly an odd beginning for an airport, this U.S. Army Corps of Engineers tug leads a string of barges containing fill to be dumped in Lake Erie to help create the new Burke Lakefront Airport. The photograph was taken in April 1947. (Cleveland Press Collection, Cleveland State University.)

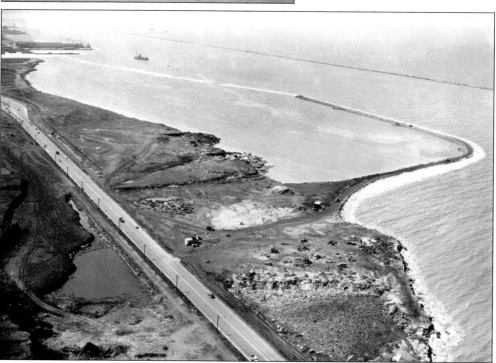

Constructed entirely on fill, the outline of Burke Lakefront Airport has begun to take shape in this photograph taken in April 1947. (Cleveland Press Collection, Cleveland State University.)

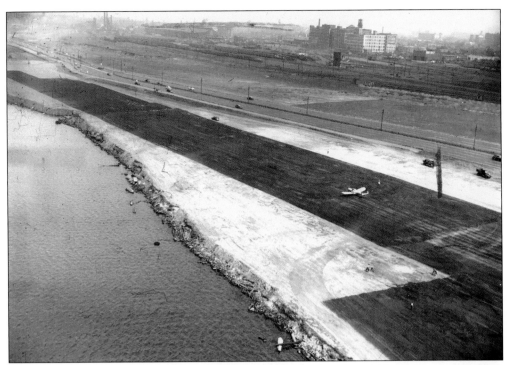

Progress on the construction of Burke Lakefront Airport was made quickly. On August 25, 1947, this photograph was taken, showing an Ercoupe making the airport's first landing. (Cleveland Press Collection, Cleveland State University.)

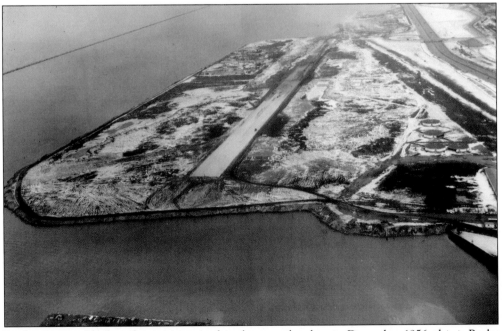

Looking pretty bleak and uninviting in this photograph taken in December 1956, this is Burke Lakefront Airport looking to the east. The submarine USS *Cod* is visible in the right foreground. (Cleveland Press Collection, Cleveland State University.)

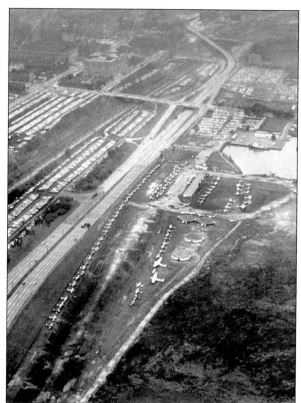

More than 100 airplanes were visible when this picture of Burke Lakefront Airport was taken in the fall of 1954. The fact that the Cleveland Indians were playing in the World Series at the time explains the unusually large number of transient aircraft. It was a short walk to the old Cleveland Municipal Stadium from the airport. (Cleveland Press Collection, Cleveland State University.)

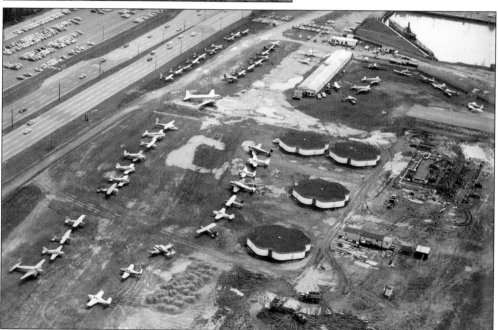

Long gone now, these quad hangars once stood where the main parking lot for Burke Lakefront Airport is now located. The picture was taken in May 1959. (Cleveland Press Collection, Cleveland State University.)

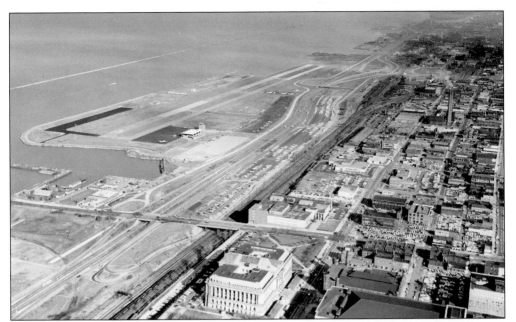

Taken in January 1961, this picture shows a pretty sparsely equipped Burke Lakefront Airport. The intersection of East Ninth Street and Lakeside Avenue is visible in the right center. With the exception of Cleveland City Hall and the Convention Center, urban renewal and interstate highway construction were about to claim many of these buildings. (Cleveland Press Collection, Cleveland State University.)

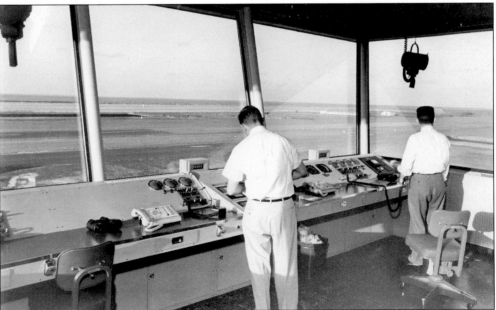

This is the interior of the control tower at Burke Lakefront Airport as it appeared in January 1962. The objects hanging from the overhead are light guns used for signaling aircraft without radios. Made from a design approved by the Civil Aeronautics Authority in the 1930s, these light guns were still in place when the author visited the control tower 35 years after this photograph was taken. (Cleveland Press Collection, Cleveland State University.)

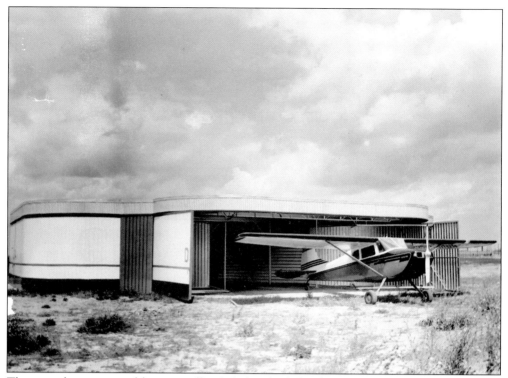

These newly constructed hangars offered shelter for light planes at Burke Lakefront Airport. When this picture was taken in August 1954, they rented for $45 a month. (Cleveland Press Collection, Cleveland State University.)

On a bleak January day in 1960, construction proceeds on the new terminal building at the Burke Lakefront Airport. (Cleveland Press Collection, Cleveland State University.)

Four

CLEVELAND AREA BUSINESS AND AIRLINE FLYING

Airline service in Cleveland began with the opening of the Cleveland Municipal Airport in the summer of 1925. Travelers could choose between sharing space with a mailbag in a fabric-covered open cockpit biplane or travel in relative comfort aboard an all-metal Ford Tri-motor, the legendary "Tin Goose." Ford sponsored an airline connecting Detroit, Cleveland, and Chicago. The trip between Cleveland and Detroit took 1 hour and 35 minutes, and a strict schedule was kept. Once Henry Ford's son Edsel arrived late and missed a departing flight by 20 minutes. His father was unsympathetic. "This is an airline, not a yacht," he said. Incredibly, Ford Tri-motors were still flying in Cleveland skies 50 years later, operated over Lake Erie by Island Airlines. Newer airplanes quickly arrived on Cleveland routes, and less than a decade after a passenger was liable to share space with mailbag, he could book a flight aboard a United Airlines Boeing 247D, an all-metal low-wing monoplane with retractable landing gear. A little more than 20 years later, the passenger might make the same trip aboard a jet.

Area businesses were quick to see the value of aircraft for executive travel, and many such aircraft have been based in Cleveland over the years, the aircraft types ranging from Cabin Wacos to Grumman Gulfstreams.

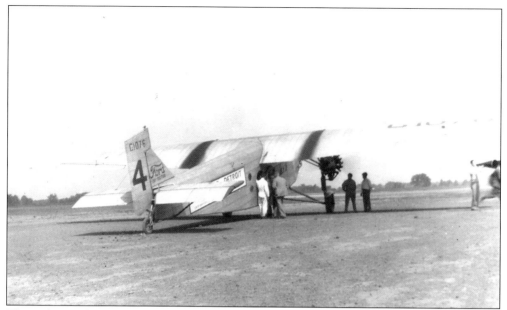

The earliest airline service joining Cleveland to other cities is seen here. The aircraft is a Ford Tri-motor. Note the heavy exhaust staining on the upper surface of the wing and the attendant with the megaphone calling out instructions on the right. (Author's collection.)

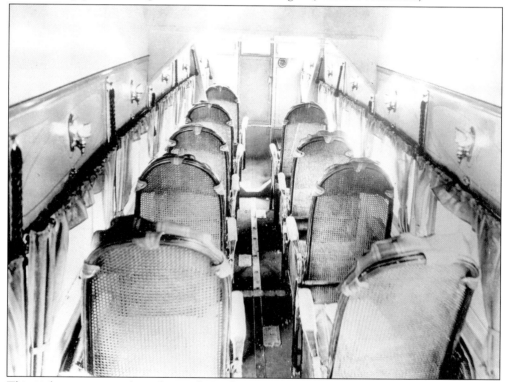

This is the passenger cabin of an early Ford Tri-motor. The wicker seats were light and strong, and each passenger had window curtains and a reading light. (Cleveland Press Collection, Cleveland State University.)

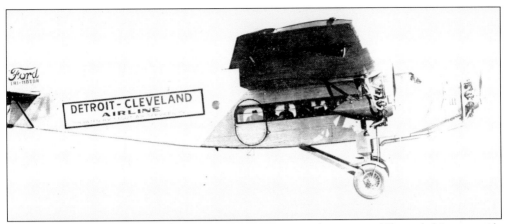

The Ford Tri-motor shown earlier is seen on its way to a destination. Through his open side window, the copilot keeps a watchful eye on the camera plane. (Cleveland Press Collection, Cleveland State University.)

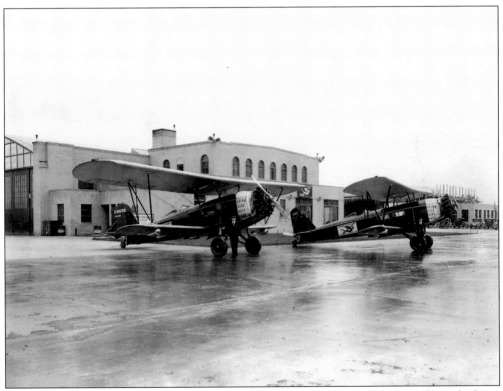

In the late 1920s and early 1930s, Stearman was well known for a successful line of large biplanes built to carry passengers and mail. Cruising at 110 miles per hour, these early airliners carried four passengers and 500 pounds of mail. Their route connected Cleveland, Akron, Columbus, Springfield, Dayton, Cincinnati, and Louisville and represented some of the area's earliest scheduled airline service. (Cleveland Press Collection, Cleveland State University.)

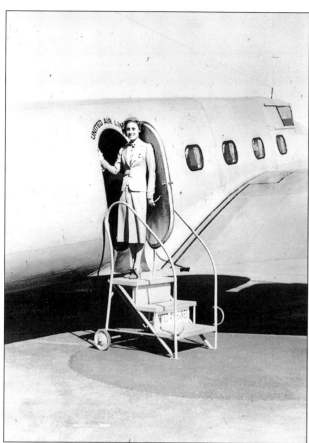

Betty Anzuena Butler flew as a stewardess for United Airlines from 1936 to 1939. She is seen here posing in the door of a Boeing 247D on the ramp at the Cleveland Municipal Airport in the summer of 1937. According to her daughter Molly Tewksbury, her mother always maintained that her time as a stewardess was the greatest adventure of her life. She was especially proud that, at a recognition event held to honor her for her airline service very late in her life, she had no difficulty fitting into the tailored uniform sewn for her more than six decades earlier. (Molly Tewksbury collection.)

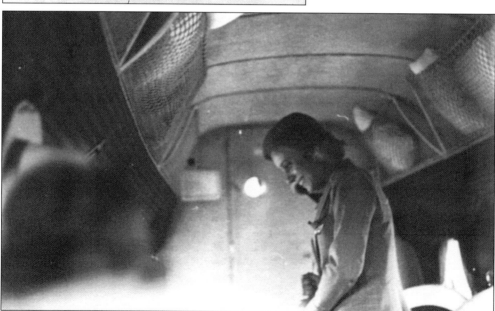

In this snapshot from 1937, United Airlines stewardess Betty Anzuena Butler tends to the needs of her passengers during a flight in a Boeing 247D. (Molly Tewksbury collection.)

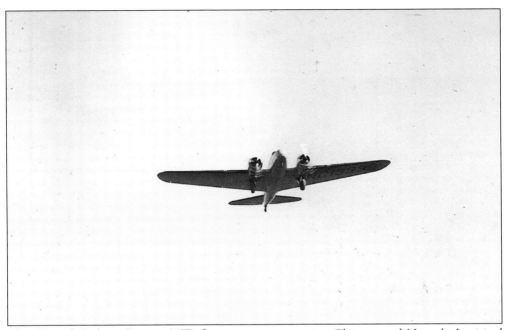

This United Airlines Boeing 247D flew a route connecting Chicago and Newark. It visited Cleveland frequently in the summer of 1937. (Molly Tewksbury collection.)

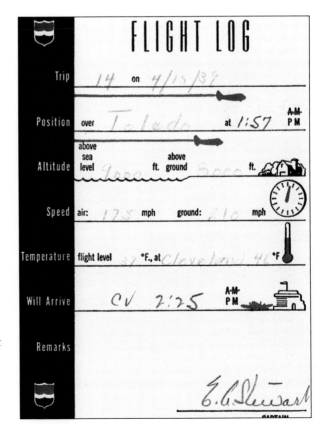

This flight log was filled out in-flight by the captain and distributed to curious United Airlines passengers to keep them informed about the progress of their flight. (Molly Tewksbury collection.)

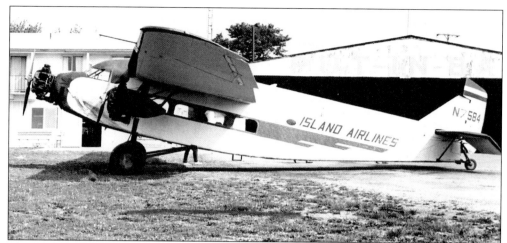

Island Airlines at Port Clinton operated Ford Tri-motors well into the 1970s. This Tri-motor was seen in October 1972. (Cleveland Press Collection, Cleveland State University.)

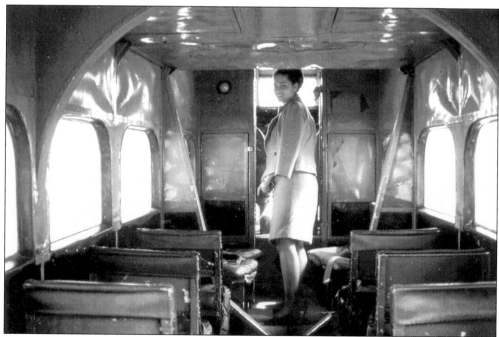

Island Airlines provided accommodations that were a little stark compared with the way these airplanes were configured when they were new. (Photograph by Pete Engelskirger)

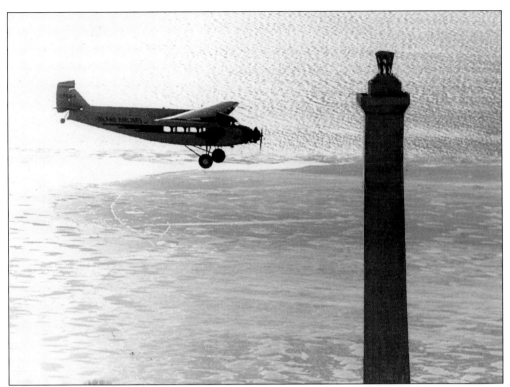

Island Airlines was a year-round operation. Here one of the Fords is seen about to fly past Perry's Monument on Put-In-Bay on a cold February day in 1971. (Cleveland Press Collection, Cleveland State University.)

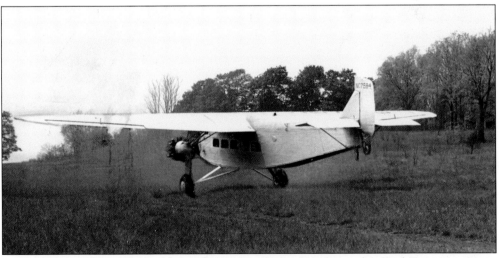

In a scene repeated regularly during the heyday of Island Airlines, this Ford Tri-motor is seen operating from the 1,500-foot runway at Rattlesnake Island, the most challenging stop along the airline's route. The picture was taken in May 1951. (Cleveland Press Collection, Cleveland State University.)

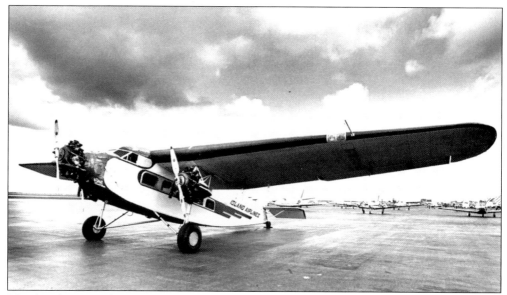

Island Airlines' Ford Tri-motor operations came to an end shortly after this picture was taken in July 1977, when an accident grounded the last airworthy Tri-motor. (Cleveland Press Collection, Cleveland State University.)

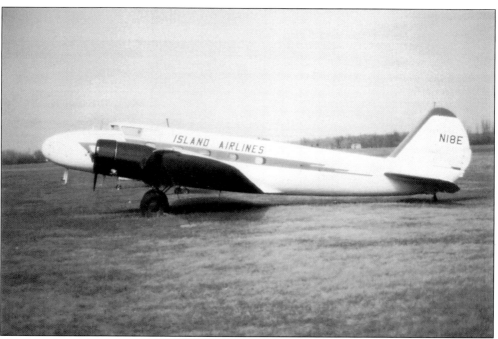

Island Airlines also operated this Boeing 247D, almost certainly the last one flown in revenue service. (Photograph by Pete Engelskirger.)

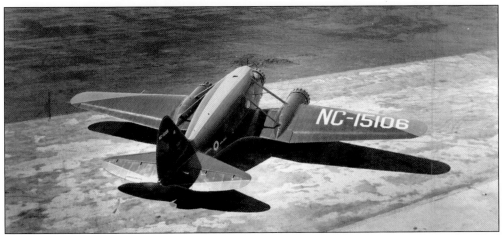

A rare bird, this Stinson Tri-motor airliner was photographed on the ramp at the Cleveland Municipal Airport during the summer of 1935. (Cleveland Press Collection, Cleveland State University.)

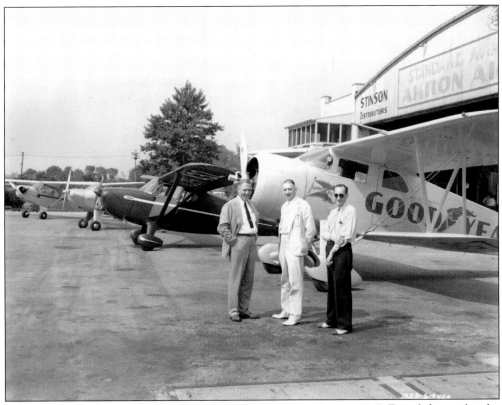

This is the equipment of the Goodyear flight department in August 1940. From left to right, the aircraft are a Piper Cub, a Luscombe, a Stinson, and a Waco SRE. While this particular model Waco is a rare sight at today's airports, examples of the other three airplanes remain in daily use in the Cleveland area to this day. (Cleveland Press Collection, Cleveland State University.)

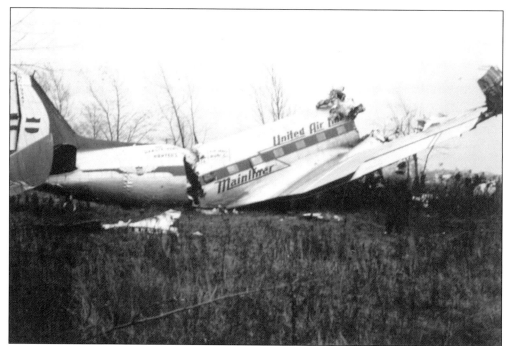

Approaching the Cleveland Municipal Airport under conditions of poor visibility, the pilots of this United Airlines DC-3 mistook the lights on the Brookpark Road Bridge for runway lights. This crash occurred as they tried to go around. (Photograph by George K. Scott; author's collection.)

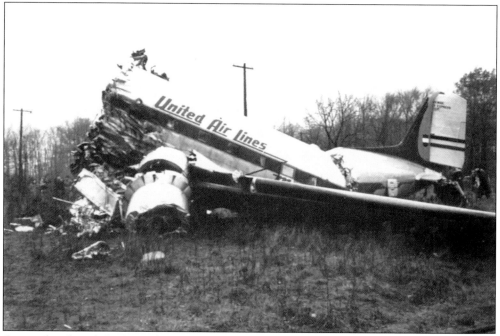

A crowd gathered the next day to gawk at the wreckage. (Photograph by George K. Scott; author's collection.)

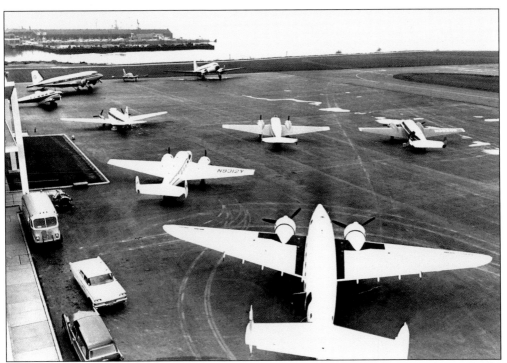

Radial-engine aircraft still dominated business aviation when this picture was taken at Burke Lakefront Airport in May 1962. (Cleveland Press Collection, Cleveland State University.)

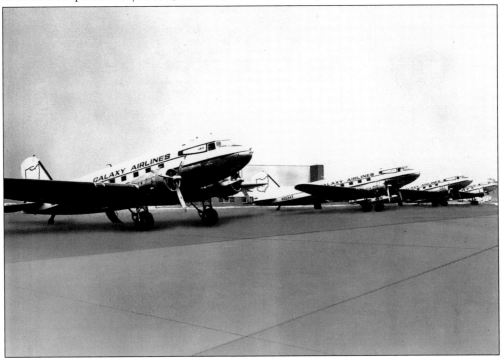

These DC-3s operated by Galaxy Airlines were seen at the Cuyahoga County Airport in July 1968. (Cleveland Press Collection, Cleveland State University.)

A sight to stir the heart of any pilot, this is the view from the copilot's window of a DC-3. The aircraft provided personal transportation for a well-to-do Cleveland family when Pete Engelskirger flew it in the early 1960s. (Photograph by Pete Engelskirger.)

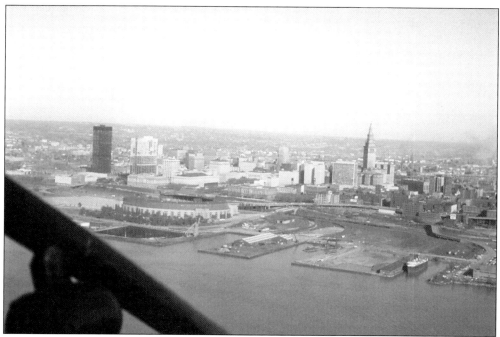

This is the Cleveland skyline, as it looked to young corporate pilot Pete Engelskirger in the mid-1960s. (Photograph by Pete Engelskirger.)

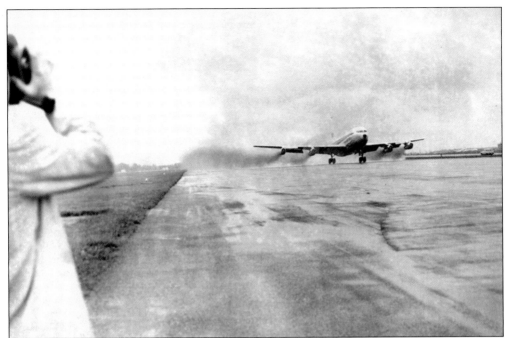

Documenting a remarkable advance in aviation technology, this photograph taken in May 1960 shows the first takeoff of a jet airliner from Cleveland Hopkins International Airport. The aircraft, a Boeing 707, was not scheduled to land at Cleveland and was diverted because of dense fog at its original destination, New York City. (Cleveland Press Collection, Cleveland State University.)

This DC-9 was the first example of its type to be seen at Cleveland Hopkins Airport. The airplane is pictured awaiting passengers in March 1965. (Cleveland Press Collection, Cleveland State University.)

These jets were parked on the north concourse at Cleveland Hopkins Airport when their picture was taken in November 1981. (Cleveland Press Collection, Cleveland State University.)

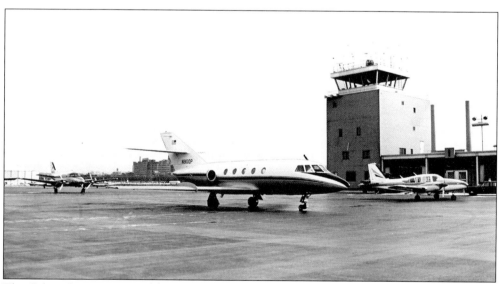

This Falcon Jet was operated by the Pickands-Mather Company, based in Cleveland, when its picture was taken at Burke Lakefront Airport in the late 1960s. (Cleveland Press Collection, Cleveland State University.)

Five

CLEVELAND AREA GENERAL AVIATION

Everyone has to start somewhere, and general aviation is the foundation upon which all other flying is based. From the first hesitant steps into the air with an instructor, through commercial flight training and instrument ratings, Cleveland aviation has seen it all for the past 80 years. Some pilots fly only for their own edification, some prepare for careers in commercial flying or the military, but all have had their place in Cleveland's aviation history. Some of the earliest businesses based at the Cleveland Municipal Airport offered flying lessons, and area flight schools took part in both the Civilian Pilot Training Program and the War Training Service before and during World War II. Many other students learned to fly in Cleveland on the G.I. Bill after the war was over.

Over the years, many smaller airports succumbed to development, but enough remain to provide a wide venue for general aviation flight operations of every sort.

Although it was taken by the author in the autumn of 2003, this photograph shows an image that would be easily recognized by several generations of Northern Ohio pilots extending back to the late 1930s. It is the view from the back seat of a Piper Cub as the airplane cruised at 70 miles per hour 1,000 feet above the sort of endless farmland that once surrounded Cleveland. (Photograph by Thomas G. Matowitz, Jr.)

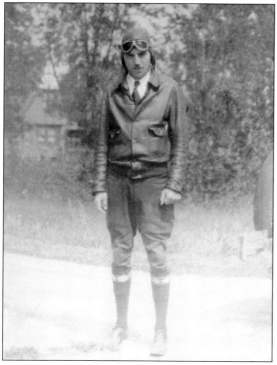

With just one of his eventual 20,000 flying hours under his belt, the author's grandfather, longtime Cleveland area flying instructor George K. Scott, was photographed here by his sister when he returned home after his first flying lesson in the summer of 1928. (Author's collection.)

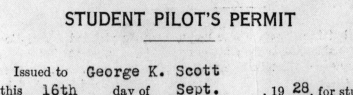

UNITED STATES OF AMERICA
DEPARTMENT OF COMMERCE
OFFICE OF THE DIRECTOR OF AERONAUTICS

STUDENT PILOT'S PERMIT

Issued to **George K. Scott**
this **16th** day of **Sept.** , 19 **28**, for student instruction with
Dungan Smith Airways Inc. at **Cleveland Airport**
Cleveland, Ohio

Unless sooner suspended or revoked, this permit expires **Sept. 15, 1929**

DESCRIPTION OF STUDENT PILOT:

Age **22** Color of hair **Brown**

Weight **142** Color of eyes **Brown**

Height **5'10"** (OVER)

STUDENT PILOT'S PERMIT NO. **4366**

Student Pilot's Signature.

The Air Commerce Act of 1926 mandated government licensing of pilots and aircraft for the first time. Once property of the author's grandfather, these documents are good examples of an early pilot's credentials issued under the terms of this new law. The number on the limited commercial pilot's license shown here indicates that Scott was among the first 5,000 pilots licensed in the United States. (Author's collection.)

PAGE 1 FORM AB-52 PAGE 6

UNITED STATES OF AMERICA
DEPARTMENT OF COMMERCE
AERONAUTICS BRANCH

LICENSE NO. **4888**

This Limited Commercial Pilot's License and attached-ed Rating Authority expires
APRIL 15 1930

Unless extended below by proper endorsement of a duly authorized inspector of the Department of Commerce.

LIMITED COMMERCIAL PILOT'S LICENSE

Issued to **GEORGE K SCOTT**
Date issued **JANUARY 11 1930**

Age **23**
Weight **150**
Height **5' 10"**
Color hair **LIGHT**
Color eyes **BROWN**

PILOT'S SIGNATURE.

LICENSE RENEWALS	
INSPECTOR'S ENDORSEMENT	EXPIRATION DATE

This Certifies *that the pilot whose photograph and signature appear hereon is a Limited Commercial Pilot of "Aircraft of the United States". The holder may pilot all classes of licensed aircraft, but may transport passengers for hire, only in such types specified in the accompanying Pilot's Rating Authority which is made a part hereof. The holder is not authorized for hire, to transport persons except in the area specified on the —— preceeding page nor to give piloting instruction to students. Unless sooner suspend- ed or revoked, this license and rating author- ity expires as indi- cated on pages 5 and 6 —— hereof.*

Note: All provisions lations are made a though written herein.

of the Air Commerce Regu- part of the terms hereof as

ASSISTANT SECRETARY OF COMMERCE FOR AERONAUTICS

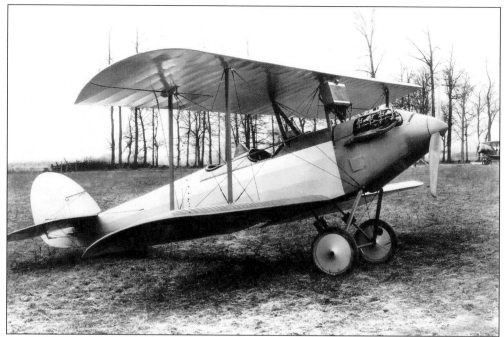

An Ohio-built aircraft, this Waco 9 was one of the best liked light planes of its day, and many flew in the Cleveland area. This airplane is equipped with the most common aircraft engine of its time, a 90 horsepower Curtiss OX-5. (Cleveland Press Collection, Cleveland State University.)

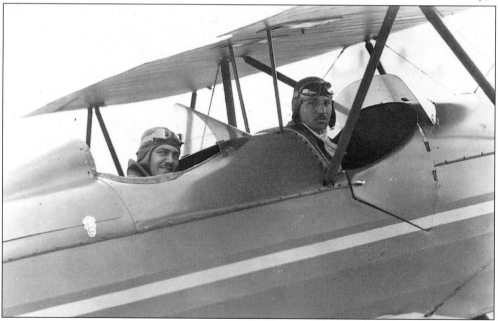

In this picture, George K. Scott, seated in the front cockpit, prepares for an instructional flight with a student, seated behind him in the rear cockpit, the position from which he was destined to solo. The airplane is a Brunner-Winkle Bird, powered by an OX-5 engine. Very highly regarded by contemporary pilots, an unusually high percentage of these fine old airplanes survive today, either actively flying or in the hands of restorers. (Author's collection.)

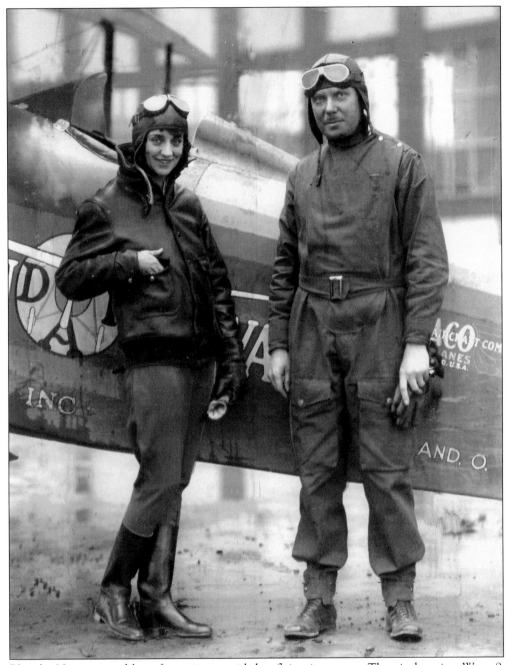

Blanche Noyes paused here for a picture with her flying instructor. The airplane is a Waco 9, and the location is the Cleveland Municipal Airport. (Cleveland Press Collection, Cleveland State University.)

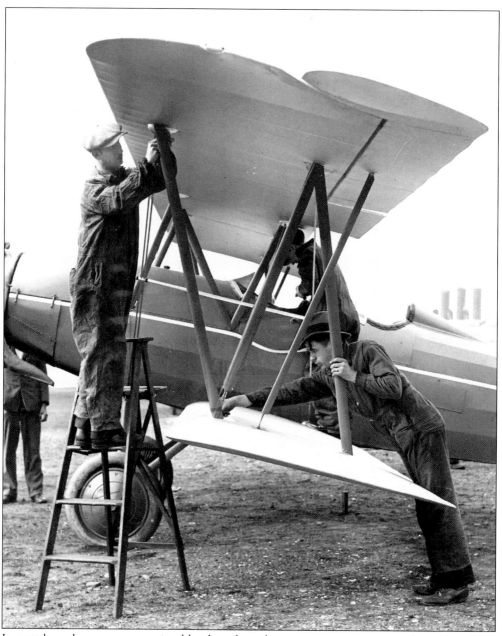

It must have been a warm spring-like day when these men were seen were pictured working on this Travel Air Biplane in March 1929. Travel Air was a direct ancestor of the Beechcraft Company, a renowned builder of light planes to this day. (Cleveland Press Collection, Cleveland State University.)

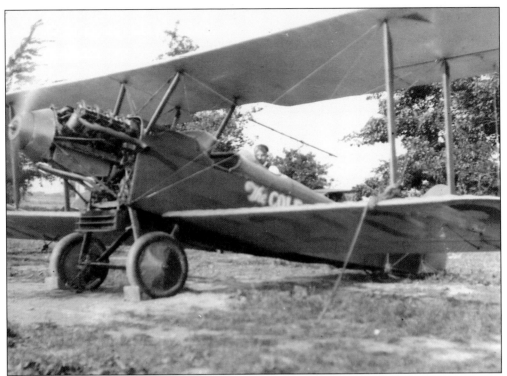

George K. Scott runs up the engine of an OX-5 Swallow during a maintenance check. The picture was taken at Cole's Field on Mayfield Road. (Author's collection.)

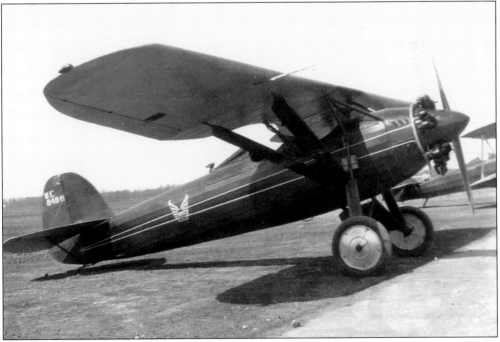

A highly regarded light plane design, this is a Davis Monoplane seen on the ramp at the Cleveland Municipal Airport on a long-ago summer day in the 1930s. (Author's collection.)

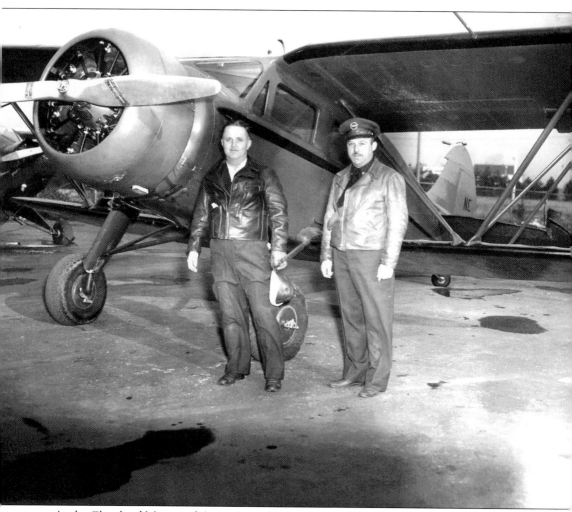

At the Cleveland Municipal Airport on a blustery day in 1942, Lloyd Evans and George K. Scott pose with a Cabin Waco belonging to Evans. Great friends for many years, Scott and Evans logged many hours together in this and other airplanes. Scott's cap and collar insignia identify him as a War Training Service flying instructor. (Author's collection.)

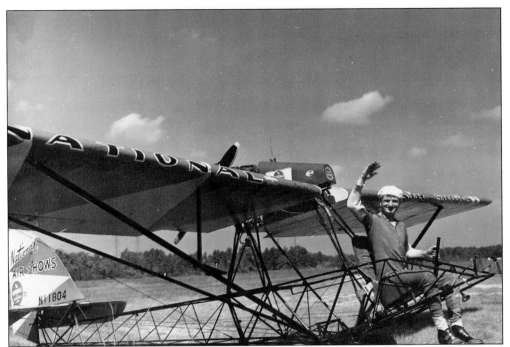

Flying for National Air Shows, pilot Danny Fowlie waves during an event at Cook Cleland's airport in Willoughby. While the airplane resembles a later day Breezy, it is actually a Curtiss Junior. (Bill Lehman collection.)

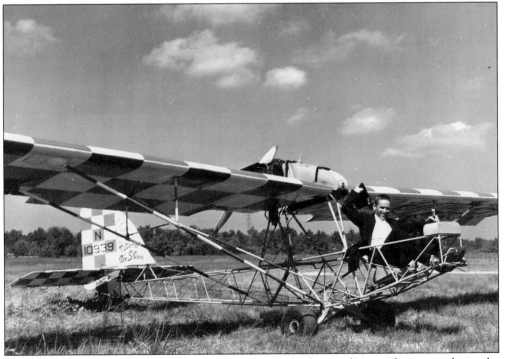

A colleague poses with a similar airplane, its Curtiss background more obvious in this wider shot. (Bill Lehman collection.)

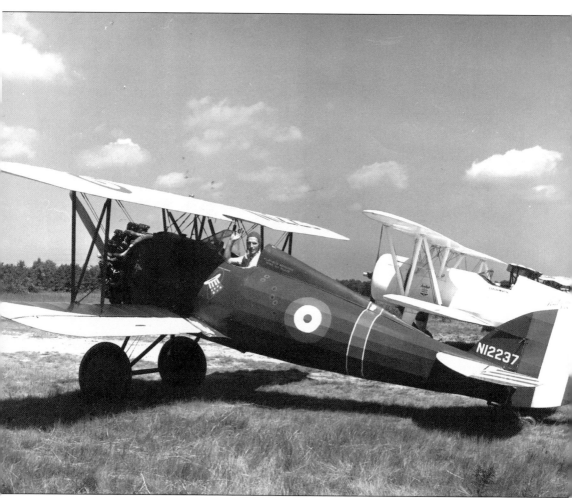

While its resemblance to a 1918 vintage Nieuport 28 is purely intentional, this airplane is actually a Garland-Lincoln built for movie work in the 1930s. Early epics like *Hell's Angels* were very hard on surviving stocks of original World War I airframes. A stand-in like this could easily fool uncritical movie audiences. It certainly pleased the crowd at Cook Cleland's air show. (Bill Lehman collection.)

Showing off for a crowd at Cook Cleland's airport in the summer of 1950, one of the air show pilots makes a low pass. (Bill Lehman collection.)

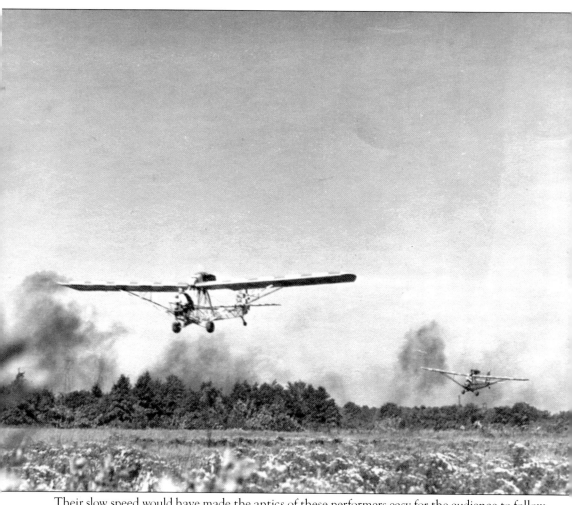

Their slow speed would have made the antics of these performers easy for the audience to follow. (Bill Lehman collection.)

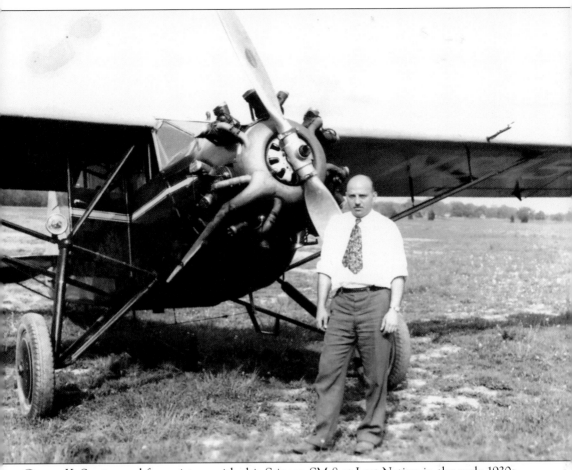

George K. Scott posed for a picture with this Stinson SM-8 at Lost Nation in the early 1930s. Stinson airplanes have always had an excellent reputation, and a number of early models like this one remain active. (Author's collection.)

This Commonwealth Skyranger is seen at the Cleveland Municipal Airport in 1941. (Photograph by George K. Scott; author's collection.)

The Aeronca Defender was a popular primary trainer when George K. Scott posed with this one at the Cleveland Municipal Airport in the early 1940s. (Author's collection.)

Another popular trainer from the same era, this is an Aeronca Champ, operated by a flight school in Cleveland just after World War II. (Photograph by George K. Scott; author's collection.)

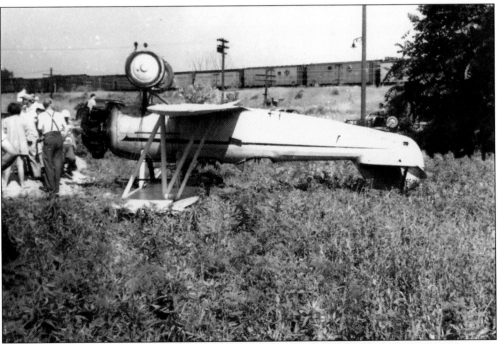

This N3N came to grief during a forced landing near Cleveland in the late 1940s. It does not appear to be badly damaged, but the availability of newer, all-metal, light planes probably made its owner think twice about repairing it. (Photograph by George K. Scott; author's collection.)

Built in Hagerstown, Maryland, the Fairchild 24 was one of the most admired light planes of its day. This one is seen at the Cleveland Municipal Airport in the late 1930s. (Photograph by George K. Scott; author's collection.)

Very highly regarded for their pleasant flying qualities, many Fairchild 24s survive, and several remain active in the Cleveland area. (Photograph by Pete Engelskirger.)

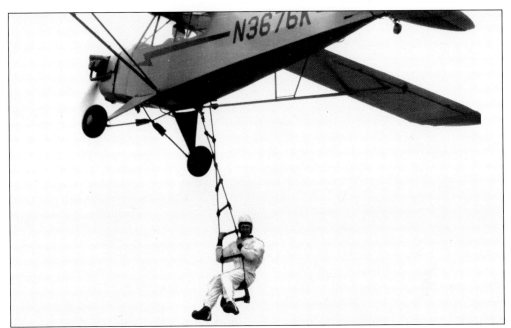

The Cleveland National Air Show was held for the first time in 1964. Pilot Don Dresselhaus holds the Cub steady for Don DeBaker on the ladder. (Cleveland Press Collection, Cleveland State University.)

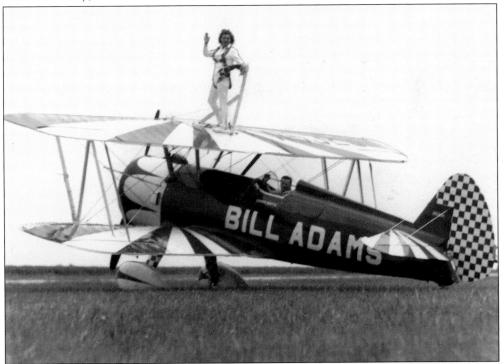

There is little doubt about the identity of the Stearman pilot at the 1964 Cleveland National Air Show. Bill Adams is joined here by wing walker Lee Marlin. (Cleveland Press Collection, Cleveland State University.)

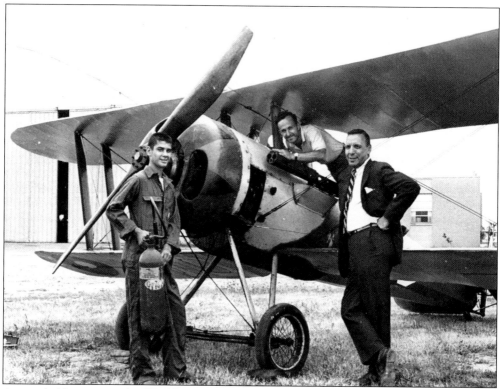

A remarkable survivor, this World War I vintage Nieuport 28 flew at the Cleveland National Air Show in the summer of 1964. (Cleveland Press Collection, Cleveland State University.)

Shown here as a carefully restored antique, this a Curtiss Junior, the same type of aircraft seen performing at Cook Cleland's air show many years earlier. (Photograph by Pete Engelskirger.)

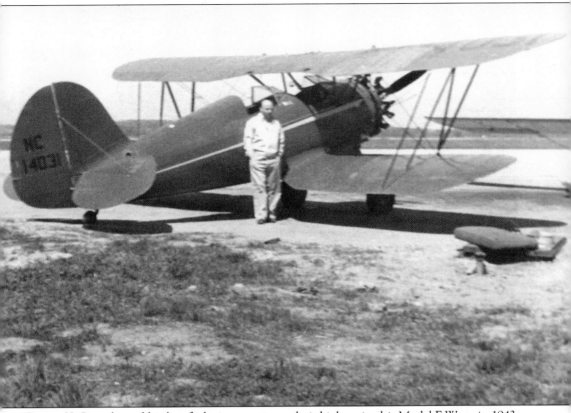

George K. Scott logged his last flight in an open cockpit biplane in this Model F Waco in 1943. (Author's collection.)

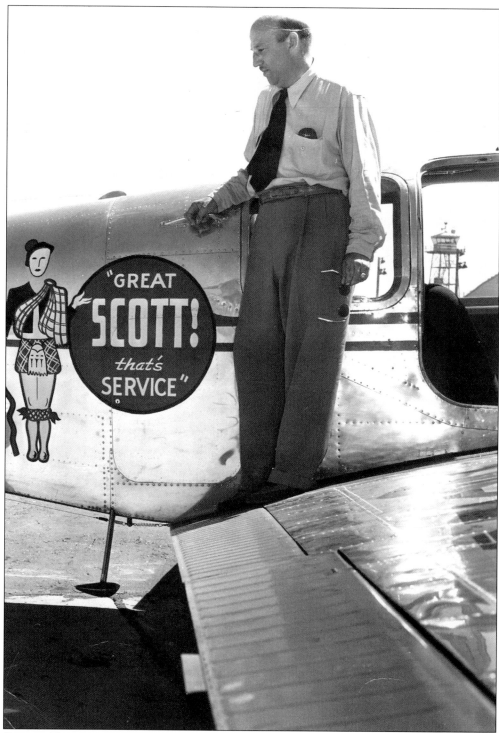

Scott and his contemporaries had come a long way in 20 years. Having learned to fly in the late 1920s in OX-5 powered biplanes, Scott was one of the first pilots to own a Beechcraft Bonanza. His Model 35 was brand new when this picture was taken in 1947. (Author's collection.)

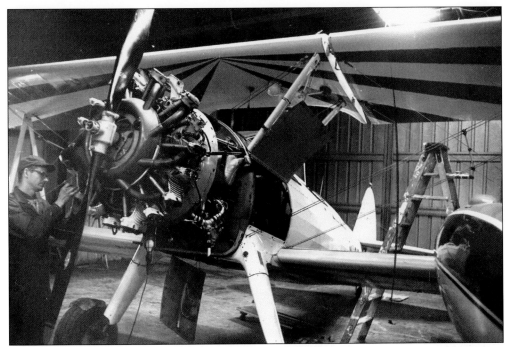

Photographed at the Medina Airport in November 1969, the author knew this airplane well in the 1970s when it belonged to his close friend, Bill Neff. (Cleveland Press Collection, Cleveland State University.)

In a picture that evokes many memories for the author, who first experienced open cockpit flying in this airplane at the age of 18, this is Neff's Stearman at Mole's Field in Grafton in the summer of 1976. (Photograph by Thomas G. Matowitz Jr.)

It is said that emergency practice should not be made too realistic. What was supposed to be a mock forced landing involving this Fairchild 21 made a lot of extra work for aircraft mechanic Bill Lehman. (Bill Lehman collection.)

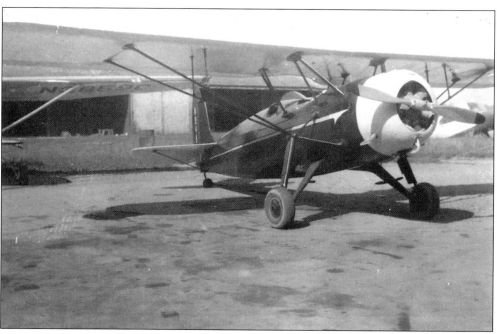

More typically powered by a Menasco inline engine, this is another view of the repaired Fairchild after Lehman got it back into the air. (Bill Lehman collection.)

A familiar detail of an airplane still certain to draw a crowd whenever one visits, this is the Wright Cyclone engine of a B-17G seen at the Cuyahoga County Airport in the 1990s. (Photograph by Thomas G. Matowitz Jr.)

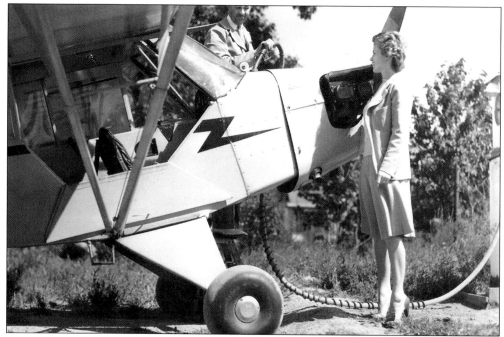

In September 1941, Arlo Mather fuels a J-3 as a prospective student looks on. Obviously a posed shot, the student would not have a prayer of managing the heel brakes with the shoes she is wearing. (Cleveland Press Collection, Cleveland State University.)

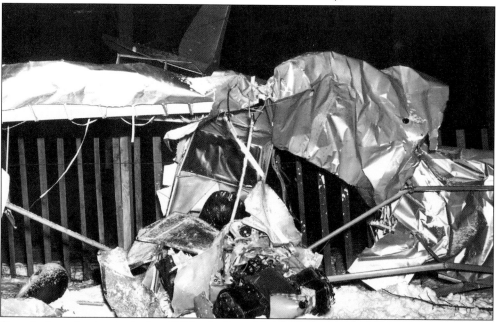

Since its introduction in the late 1930s, the Piper J-3 Cub has been prized for its docile handling. However, as this photograph grimly demonstrates, even a gentle airplane can be deadly if handled carelessly. A glance at the wreckage suggests correctly that the occupants did not survive. The crash took place in Euclid in January 1940. (Cleveland Press Collection, Cleveland State University.)

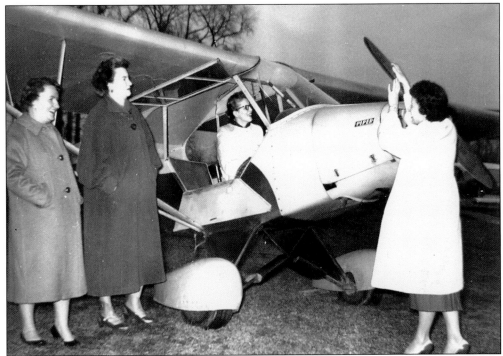

In January 1960, these ladies check out a Piper PA-11, a more advanced version of the J-3. (Cleveland Press Collection, Cleveland State University.)

In a timeless scene that has graced many Cleveland area airports over the years, a 65-horsepower tail dragger waits to fly from a grass field on a summer day. The airplane is an Aeronca Champ. (Photograph by Pete Engelskirger.)

Demonstrating the use of a light plane as practical transportation, friends Jerry Chvosta and Jerry Noss prepare to leave on a trip to Canada in June 1961. Their aircraft is a Stinson, and they were photographed as they were about to depart from the Chardon Airport. (Cleveland Press Collection, Cleveland State University.)

In May 1956, Goodyear tested an experimental aircraft tire called a Terra-Tire on this Stinson Voyager. The test involved a high-speed taxi over obstacles to check the aircraft's ground handling when equipped with these new tires. (Cleveland Press Collection, Cleveland State University.)

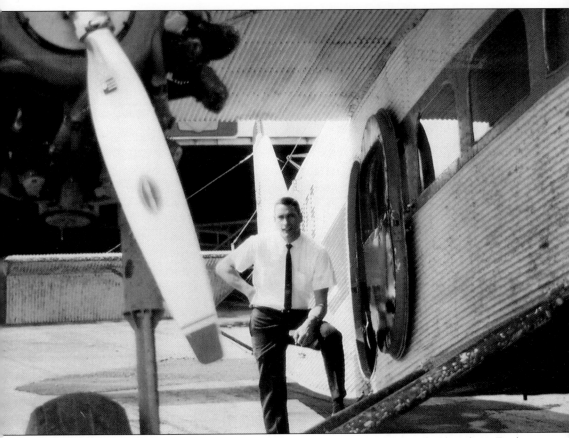

Early in his own career as a corporate pilot, Pete Engelskirger checks out an Island Airlines Ford Tri-motor. (Pete Engelskirger collection.)

Not exactly an idea whose time had come, this experimental inflatable airplane was tested by Goodyear in the mid-1950s. Pilot Dick Ulm was at the controls when this picture was taken at the Wingfoot Lake Airship Base in January 1956. (Cleveland Press Collection, Cleveland State University.)

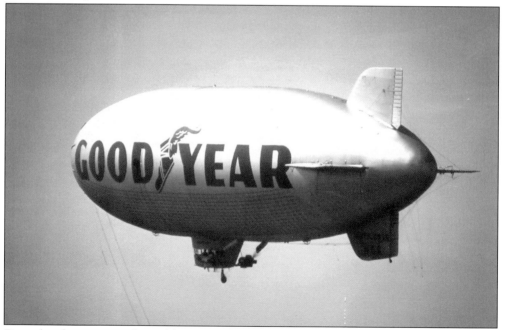

Since their base is so nearby in Akron, Goodyear Blimps have always been a familiar sight in the skies over Cleveland. (Photograph by Pete Engelskirger.)

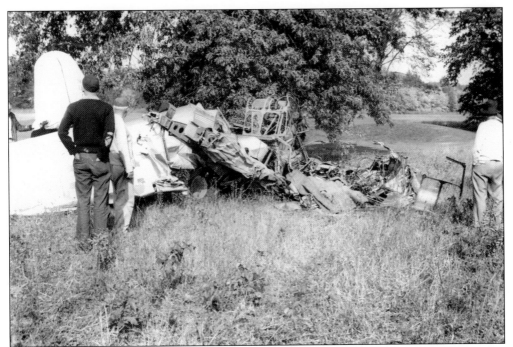

For many years, 1946 was said to have been the worst year for accidents in U.S. Civil Aviation history. This BT-13 was demolished that year in a manner that gave the pilot little chance of survival. (Photograph by George K. Scott; author's collection.)

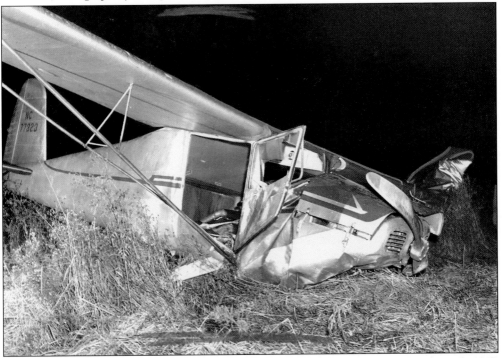

This Cessna's flying days appear to be over. The accident happened on October 15, 1947. (Cleveland Press Collection, Cleveland State University.)

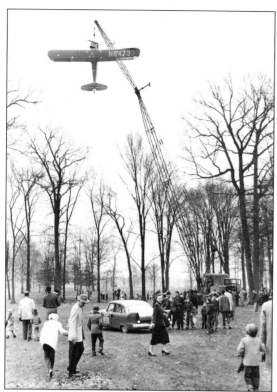

In one of the area's more bizarre aircraft accidents, this Taylorcraft wound up in the tree tops at the Mayfield Heights Country Club on the last day of 1957. (Cleveland Press Collection, Cleveland State University.)

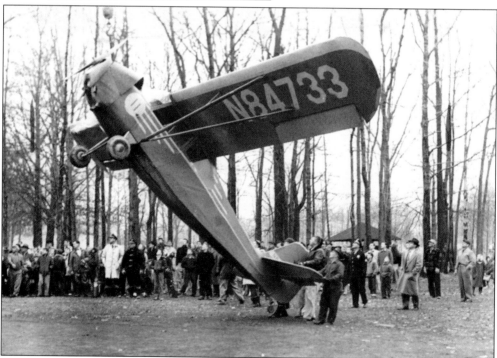

Not looking much the worse for wear, the airplane is gently lowered to the ground. It may well have lived to fly another day. (Cleveland Press Collection, Cleveland State University.)

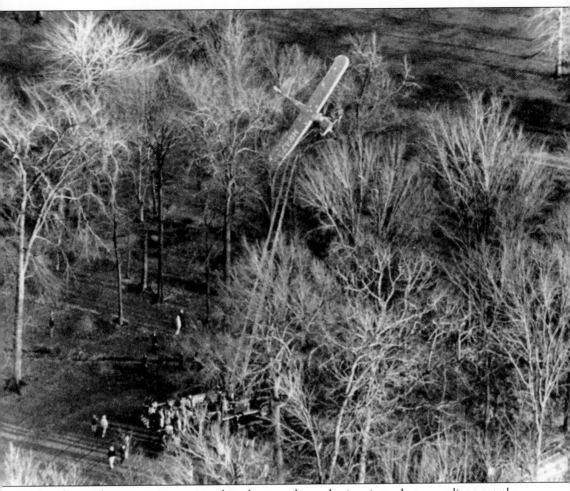

Taken from a better vantage point, this photograph emphasizes just what a predicament the occupants of this airplane faced before being rescued. (Cleveland Press Collection, Cleveland State University.)

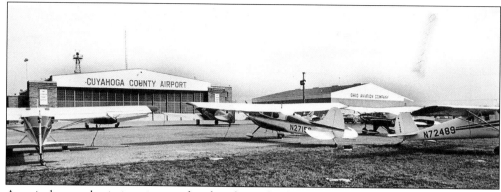

A typical general aviation airport of its day, this is the Cuyahoga County Airport as it was in the summer of 1964. (Cleveland Press Collection, Cleveland State University.)

Seen here with its original radial engine, this Ohio-built Dart was fully aerobatic, and a well-liked airplane in its day. At least one remains active in the Cleveland area. (Photograph by Pete Engelskirger.)

This Taylorcraft is another Ohio-built aircraft that remains popular with grassroots pilots in the Cleveland area. (Photograph by Pete Engelskirger.)

The Piper Colt was a transitional airplane for the company. Still a fabric-covered design, it has tricycle landing gear which was becoming very popular when the airplane was introduced. Many Cleveland-area students learned how to fly in one in the 1960s and 1970s. (Photograph by Pete Engelskirger.)

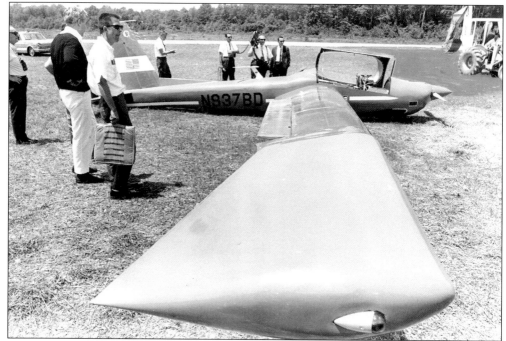

Jim Bede's BD-2 motor glider was one of the more unusual airplanes to operate from the Cuyahoga County Airport. The picture was taken July 4, 1967. (Cleveland Press Collection, Cleveland State University.)

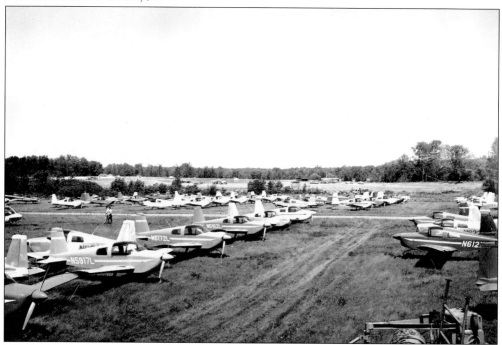

These are newly built Grumman American Yankees awaiting delivery to their owners in July 1973. They were built at the Cuyahoga County Airport. (Cleveland Press Collection, Cleveland State University.)

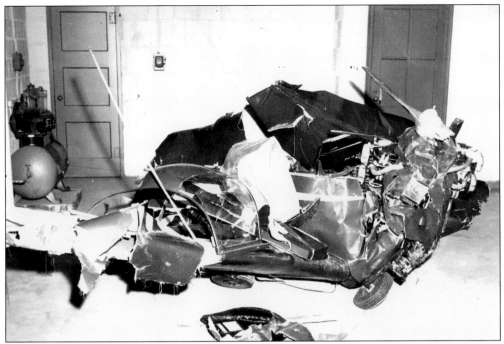

This wrecked Mooney Mite was transported to the Cuyahoga County Airport so examiners could study it to try to determine why it crashed. The incident occurred in August 1955. (Cleveland Press Collection, Cleveland State University.)

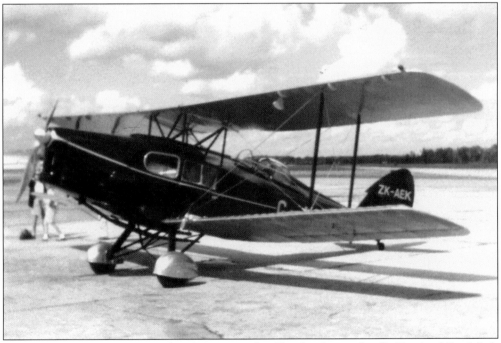

A very unusual transient aircraft to be seen in the Cleveland area, this DeHaviland Fox Moth was visiting all the way from New Zealand the day Bill Lehman spotted it at Lost Nation. (Bill Lehman collection.)

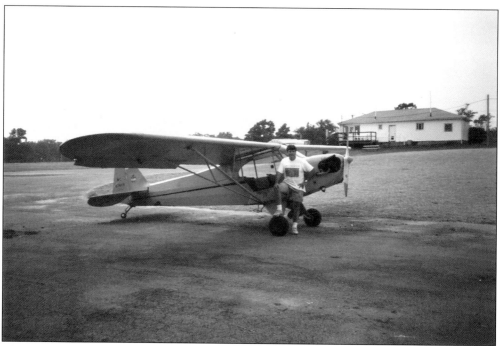

This is the author at the start of his apprenticeship as a tail wheel pilot in the summer of 1999. The airplane is a Piper Cub built in 1946. (Author's collection.)

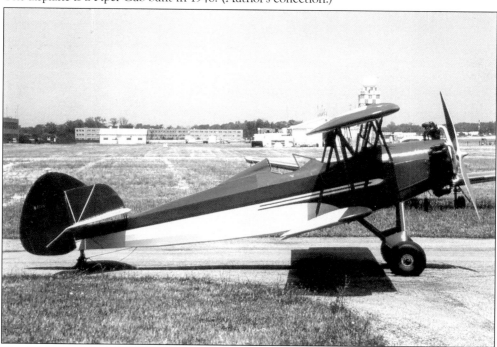

This Fleet Model 7 was a familiar sight in Cleveland skies for 30 years. Its owner was Everett Dyer, a corporate pilot and a very capable instructor of aerobatics and tail wheel flying skills. A gracious man with a large store of patience for those who wished to learn, he left many friends. (Photograph by Pete Engelskirger.)

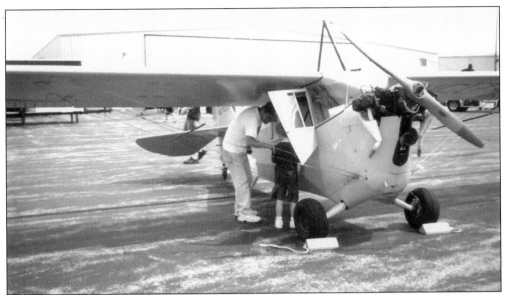

A rare sight nowadays, this Aeronca C-3 was a popular light plane in the 1930s. A very basic airplane, the earliest versions flew with engines of just 37 horsepower. This aircraft was seen at an air show at Lost Nation in the summer of 2007, 70 years after it first flew. (Bill Lehman collection.)

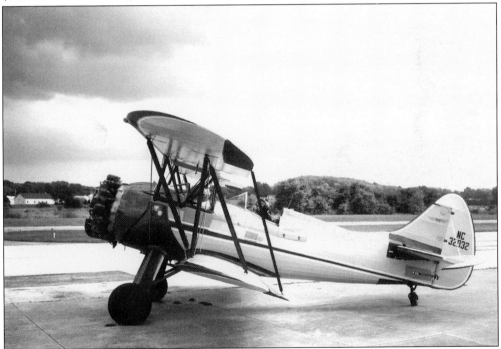

At the controls of his 1941 Waco UPF-7, Pete Engelskirger prepares to take passengers for a ride at the Wadsworth Airport in this photograph from the summer of 2002. Engelskirger came to Cleveland to find work in aviation in 1961 and recently retired from the left seat of a Grumman Gulfstream. Active as a flying instructor for many years, he has been a good friend and a mentor to Cleveland pilots for more than 40 years. (Photograph by Thomas G. Matowitz Jr.)

DISCOVER THOUSANDS OF LOCAL HISTORY BOOKS
FEATURING MILLIONS OF VINTAGE IMAGES

Arcadia Publishing, the leading local history publisher in the United States, is committed to making history accessible and meaningful through publishing books that celebrate and preserve the heritage of America's people and places.

Find more books like this at
www.arcadiapublishing.com

Search for your hometown history, your old stomping grounds, and even your favorite sports team.

Consistent with our mission to preserve history on a local level, this book was printed in South Carolina on American-made paper and manufactured entirely in the United States. Products carrying the accredited Forest Stewardship Council (FSC) label are printed on 100 percent FSC-certified paper.